Francis Frith's
Hampshire
Churches

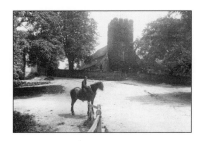

Photographic Memories

Francis Frith's
Hampshire Churches

Nick Channer

THE FRANCIS FRITH COLLECTION

FRITH
BOOK Co

First published in the United Kingdom in 2001 by
Frith Book Company Ltd

Paperback Edition 2001
ISBN 1-85937-207-4

British Library Cataloguing in Publication Data

Francis Frith's Hampshire Churches
Nick Channer

Frith Book Company Ltd
Frith's Barn, Teffont,
Salisbury, Wiltshire SP3 5QP
Tel: +44 (0) 1722 716 376
Email: info@francisfrith.co.uk
www.francisfrith.co.uk

Printed and bound in Great Britain

Front Cover: Longparish, The Church 1899 43700

AS WITH ANY HISTORICAL DATABASE THE FRITH ARCHIVE IS CONSTANTLY BEING CORRECTED AND IMPROVED
AND THE PUBLISHERS WOULD WELCOME INFORMATION ON OMISSIONS OR INACCURACIES

Contents

Francis Frith: *Victorian Pioneer*

FRANCIS FRITH, Victorian founder of the world-famous photographic archive, was a complex and multi-talented man. A devout Quaker and a highly successful Victorian businessman, he was both philosophic by nature and pioneering in outlook.

By 1855 Francis Frith had already established a wholesale grocery business in Liverpool, and sold it for the astonishing sum of £200,000, which is the equivalent today of over £15,000,000. Now a multi-millionaire, he was able to indulge his passion for travel. As a child he had pored over travel books written by early explorers, and his fancy and imagination had been stirred by family holidays to the sublime mountain regions of Wales and Scotland. 'What a land of spirit-stirring and enriching scenes and places!' he had written. He was to return to these scenes of grandeur in later years to 'recapture the thousands of vivid and tender memories', but with a different purpose. Now in his thirties, and captivated by the new science of photography, Frith set out on a series of pioneering journeys to the Nile regions that occupied him from 1856 until 1860.

Intrigue and Adventure

He took with him on his travels a specially-designed wicker carriage that acted as both dark-room and sleeping chamber. These far-flung journeys were packed with intrigue and adventure. In his life story, written when he was sixty-three, Frith tells of being held captive by bandits, and of fighting 'an awful midnight battle to the very point of surrender with a deadly pack of hungry, wild dogs'. Sporting flowing Arab costume, Frith arrived at Akaba by camel seventy years before Lawrence, where he encountered 'desert princes and rival sheikhs, blazing with jewel-hilted swords'.

During these extraordinary adventures he was assiduously exploring the desert regions bordering the Nile and patiently recording the antiquities and peoples with his camera. He was the first photographer to venture beyond the sixth cataract. Africa was still the mysterious 'Dark Continent', and Stanley and Livingstone's historic meeting was a decade into the future. The conditions for picture taking confound belief. He laboured for hours in his wicker dark-room in the sweltering heat of the desert, while the volatile chemicals fizzed dangerously in their trays. Often he was forced to work in remote tombs and caves where conditions were cooler. Back in London he exhibited his photographs and was 'rapturously cheered' by members of the Royal Society. His reputation as a

photographer was made overnight. An eminent modern historian has likened their impact on the population of the time to that on our own generation of the first photographs taken on the surface of the moon.

Venture of a Life-Time

Characteristically, Frith quickly spotted the opportunity to create a new business as a specialist publisher of photographs. He lived in an era of immense and sometimes violent change. For the poor in the early part of Victoria's reign work was a drudge and the hours long, and people had precious little free time to enjoy themselves. Most had no transport other than a cart or gig at their disposal, and had not travelled far beyond the boundaries of their own town or village. However,

by the 1870s, the railways had threaded their way across the country, and Bank Holidays and half-day Saturdays had been made obligatory by Act of Parliament. All of a sudden the ordinary working man and his family were able to enjoy days out and see a little more of the world.

With characteristic business acumen, Francis Frith foresaw that these new tourists would enjoy having souvenirs to commemorate their days out. In 1860 he married Mary Ann Rosling and set out with the intention of photographing every city, town and village in Britain. For the next thirty years he travelled the country by train and by pony and trap, producing fine photographs of seaside resorts and beauty spots that were keenly bought by millions of Victorians. These prints were painstakingly pasted into family albums and pored over during the dark nights of winter, rekindling precious memories of summer excursions.

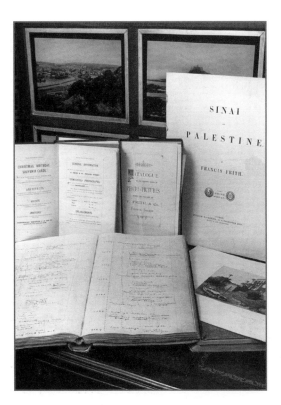

The Rise of Frith & Co

Frith's studio was soon supplying retail shops all over the country. To meet the demand he gathered about him a small team of photographers, and published the work of independent artist-photographers of the calibre of Roger Fenton and Francis Bedford. In order to gain some understanding of the scale of Frith's business one only has to look at the catalogue issued by Frith & Co in 1886: it runs to some 670 pages, listing not only many thousands of views of the British Isles but also many photographs of most European countries, and China, Japan, the USA and Canada – note the sample page shown above from the hand-written *Frith & Co* ledgers detailing pictures taken. By 1890 Frith had created the greatest specialist photographic publishing company in the world,

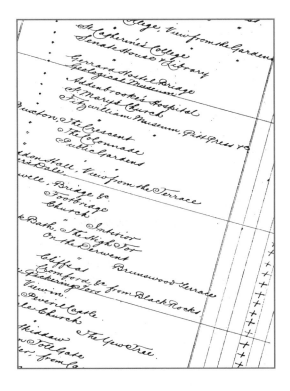

Frith's death, a new card measuring 5.5 x 3.5 inches became the standard format, but it was not until 1902 that the divided back came into being, with address and message on one face and a full-size illustration on the other. *Frith & Co* were in the vanguard of postcard development, and Frith's sons Eustace and Cyril continued their father's monumental task, expanding the number of views offered to the public and recording more and more places in Britain, as the coasts and countryside were opened up to mass travel.

Francis Frith died in 1898 at his villa in Cannes, his great project still growing. The archive he created continued in business for another seventy years. By 1970 it contained over a third of a million pictures of 7,000 cities, towns and villages. The massive photographic record Frith has left to us stands as a living monument to a special and very remarkable man.

with over 2,000 outlets – more than the combined number that Boots and WH Smith have today! The picture on the right shows the *Frith & Co* display board at Ingleton in the Yorkshire Dales. Beautifully constructed with mahogany frame and gilt inserts, it could display up to a dozen local scenes.

Postcard Bonanza

The ever-popular holiday postcard we know today took many years to develop. In 1870 the Post Office issued the first plain cards, with a pre-printed stamp on one face. In 1894 they allowed other publishers' cards to be sent through the mail with an attached adhesive halfpenny stamp. Demand grew rapidly, and in 1895 a new size of postcard was permitted called the court card, but there was little room for illustration. In 1899, a year after

Frith's Archive: *A Unique Legacy*

FRANCIS FRITH'S legacy to us today is of immense significance and value, for the magnificent archive of evocative photographs he created provides a unique record of change in 7,000 cities, towns and villages throughout Britain over a century and more. Frith and his fellow studio photographers revisited locations many times down the years to update their views, compiling for us an enthralling and colourful pageant of British life and character.

We tend to think of Frith's sepia views of Britain as nostalgic, for most of us use them to conjure up memories of places in our own lives with which we have family associations. It often makes us forget that to Francis Frith they were records of daily life as it was actually being lived in the cities, towns and villages of his day. The Victorian age was one of great and often bewildering change for ordinary people, and though the pictures evoke an impression of slower times, life was as busy and hectic as it is today.

We are fortunate that Frith was a photographer of the people, dedicated to recording the minutiae of everyday life. For it is this sheer wealth of visual data, the painstaking chronicle of changes in dress, transport, street layouts, buildings, housing, engineering and landscape that captivates us so much today. His remarkable images offer us a powerful link with the past and with the lives of our ancestors.

Today's Technology

Computers have now made it possible for Frith's many thousands of images to be accessed almost instantly. In the Frith archive today, each photograph is carefully 'digitised' then stored on a CD Rom. Frith archivists can locate a single photograph amongst thousands within seconds. Views can be catalogued and sorted under a variety of categories of place and content to the immediate benefit of researchers.

Inexpensive reference prints can be created for them at the touch of a mouse button, and a wide range of books and other printed materials assembled and published for a wider, more general readership - in the next twelve months over a hundred Frith local history titles will be published! The day-to-day workings of the archive are very different from how they were in Francis Frith's time: imagine the herculean task of sorting through eleven tons of glass negatives as Frith had to do to locate a particular sequence of pictures! Yet

See Frith at www. frithbook.co.uk

the archive still prides itself on maintaining the same high standards of excellence laid down by Francis Frith, including the painstaking cataloguing and indexing of every view.

It is curious to reflect on how the internet now allows researchers in America and elsewhere greater instant access to the archive than Frith himself ever enjoyed. Many thousands of individual views can be called up on screen within seconds on one of the Frith internet sites, enabling people living continents away to revisit the streets of their ancestral home town, or view places in Britain where they have enjoyed holidays. Many overseas researchers welcome the chance to view special theme selections, such as transport, sports, costume and ancient monuments.

We are certain that Francis Frith would have heartily approved of these modern developments in imaging techniques, for he himself was always working at the very limits of Victorian photographic technology.

The Value of the Archive Today

Because of the benefits brought by the computer, Frith's images are increasingly studied by social historians, by researchers into genealogy and ancestory, by architects, town planners, and by teachers and schoolchildren involved in local history projects.

In addition, the archive offers every one of us an opportunity to examine the places where we and our families have lived and worked down the years. Highly successful in Frith's own era, the archive is now, a century and more on, entering a new phase of popularity.

The Past in Tune with the Future

Historians consider the Francis Frith Collection to be of prime national importance. It is the only archive of its kind remaining in private ownership and has been valued at a million pounds. However, this figure is now rapidly increasing as digital technology enables more and more people around the world to enjoy its benefits.

Francis Frith's archive is now housed in an historic timber barn in the beautiful village of Teffont in Wiltshire. Its founder would not recognize the archive office as it is today. In place of the many thousands of dusty boxes containing glass plate negatives and an all-pervading odour of photographic chemicals, there are now ranks of computer screens. He would be amazed to watch his images travelling round the world at unimaginable speeds through network and internet lines.

The archive's future is both bright and exciting. Francis Frith, with his unshakeable belief in making photographs available to the greatest number of people, would undoubtedly approve of what is being done today with his lifetime's work. His photographs, depicting our shared past, are now bringing pleasure and enlightenment to millions around the world a century and more after his death.

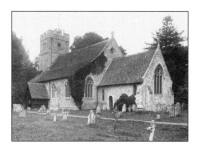

Hampshire Churches
An Introduction

Hampshire is one of those classic counties that seem to capture the spirit and beauty of the English countryside. Stretching from the genteel yachting haven of Lymington in the west to Surrey's manicured commuter belt in the east, it has often been said that Hampshire has something for everyone. With its charming villages, rolling farmland, scenic river valleys and glorious forests, the county's attractions are many and varied. And, of course, there is its bracing coastline, littered with monuments to the past and a permanent reminder of how this country defended itself against attack over the centuries.

At the heart of Hampshire's wide countryside lie its villages, one of the key elements that have helped to shape the rural character of this country over the centuries. Our village communities are woven into the fabric of our society, reflecting a way of life that is unique throughout the world. Hampshire is blessed with many fine villages. We may be thankful that they have stood the test of time and have remained largely intact, although some have fallen victim to planning blight and have seen their boundaries expand in recent years, while others have witnessed the closure of shops, schools and pubs within their community.

However, one landmark on the village map remains reassuringly timeless: the parish church. These sacred buildings play a vital role in the day-to-day life of the community, as well as being an integral

part of our heritage. They illustrate the continuity of Christian worship, and it is vital that we protect them and look after them for future generations.

Churches began by playing a pivotal role in the parochial system, and were served originally by one priest. It was his duty to ensure that his flock received proper advice and guidance. Parish church plans developed in erratic fashion, though generally reflecting the growth, wealth and piety of the local community and the nation. Over the years they acquired chapels and aisles, founded by philanthropic merchants or local benefactors.

But churches are not simply grand places of worship, constructed to meet the spiritual needs of their parishioners. They are invariably buildings of great architectural beauty, filled with riches that have gladdened the eye for centuries. However, churches were rarely easy to build. The sheer scale and size of them often made construction work lengthy and laborious. But essentially these great buildings stand as a lasting testimony to the skill and ingenuity of their craftsmen. No-one can fail to be impressed by the simple lines of a church tower standing out against the skyline or the breathtaking, intricate detail of stained glass.

Different periods reflect different styles and trends, from Saxon and Norman to Early English, Perpendicular and Victorian. Hampshire boasts many fine churches which highlight the changing architectural styles of the centuries. There is evidence of Saxon work in a number of the county's churches, while the familiar Norman stamp crops up everywhere. The north doorway at Crondall and the south door at Winchfield are typical examples.

It is not just the architectural splendour of our churches that impresses us, but their ancient customs and historic associations with notable figures from our past. For example, the church at Abbotts Ann is remembered for its garlands which attended the funerals of village maidens, while Chawton Church is a favourite of Jane Austen devotees - her mother and sister are buried here. The churchyard at West Meon is the final resting place of a cricketing legend and also of a famous traitor who fled these shores in the 1950s. Then there is Charles Kingsley, who was not only a well-known writer but a Hampshire rector for many years during the 19th century.

The best way to appreciate Hampshire's rich variety of churches is to visit them. If you are feeling energetic, you could even journey from church to church on foot, using Hampshire's sprawling network of paths and tracks. Our public rights of way are inextricably linked with community life: long before the motor car was invented, these routes evolved as a vital means of communication. Different generations used them as they went to work in the fields and factories, or travelled to school, market or church.

In this more hostile and violent age, it is perhaps not surprising that many of our country churches are locked during the week. However, many are open and welcome visitors at any time of the day. The church itself may conceal a wealth of treasures within its walls, but often the churchyard reveals a great deal about its parishioners and those who supported the church and were key figures in the parish over the years. Monuments and memorials, too, tell us much about the history of our churches and how they relate to the villages in which they are situated. A parish church reflects the social and economic background of a village as no other building can possibly do.

Much in our world has changed since the photographs in this guide were taken by Francis Frith and his team of professionals; let us be thankful that our splendid English churches and their unique character remain the same.

Around Petersfield

Clanfield, St James's Church c1955 C574006
Situated at the western end of the South Downs,
Clanfield Church dates back to the 19th century.
It retains a 15th-century font from the old church,
as well as a splendid window and a 17th-century
chalice.

Steep, All Saints Church 1898 41358
The partly Norman church of All Saints includes a Victorian bell turret, a lychgate and several memorials, including one to Basil Marden who was killed in an avalanche in the Andes in 1928. There is a memorial window, too, dedicated to the Edwardian poet Edward Thomas who lived locally and was killed in the First World War. Dedicated in 1978, the centenary of Thomas's birth, the window was designed and engraved by Laurence Whistler.

Hawkley, The Village and The Church of St Peter and St Paul 1901 46609A
The green and the surrounding roads and houses may look a little different today, one hundred years after this photograph was taken, but one landmark remains reassuringly constant and permanent: Hawkley's famous church, partly screened by a curtain of yew trees. The tower can be seen from miles around.

Hawkley
The Church of St Peter and St Paul c1960 H424018
Hawkley's most distinctive feature is the tall tower of its church, characterised by a round staircase turret and a steep four-gabled cap, similar to the Saxon tower at Sompting in Sussex. Inside the church is a 700-year-old font, four 15th-century bells and a 15th-century alabaster panel of the Betrayal of Jesus, a superb example of medieval art.

East Meon
All Saints Church c1955 E173010
East Meon's sturdy church dates back 800 years. Its walls are over four feet thick and may well have been built by Bishop Walkelin, cousin of William the Conqueror. The lychgate was built in memory of a popular local doctor. The striking 12th-century tower is supported on four Norman arches with scalloped capitals.

Bramshott, The Church of St Mary 1901 46581
Standing amid yew trees and banks of foliage, Bramshott's church boasts a medieval font, an 18th-century candelabra and a case containing pottery bowls found in the mortar of the tower. One of the chancel lancets has little figures depicted in ancient glass, and the 32 years' service of a 19th-century rector is also commemorated in glass.

Buriton, The Church of St Mary 1898 41370
The picturesque village of Buriton stands in the shadow of Butser Hill, and by the pretty, tree-fringed pond lies the church, with its 13th-century tower watching over the tranquil scene. The low font is Norman, as are the arches, which stand on pillars carved with water lilies, foliage and scallops.

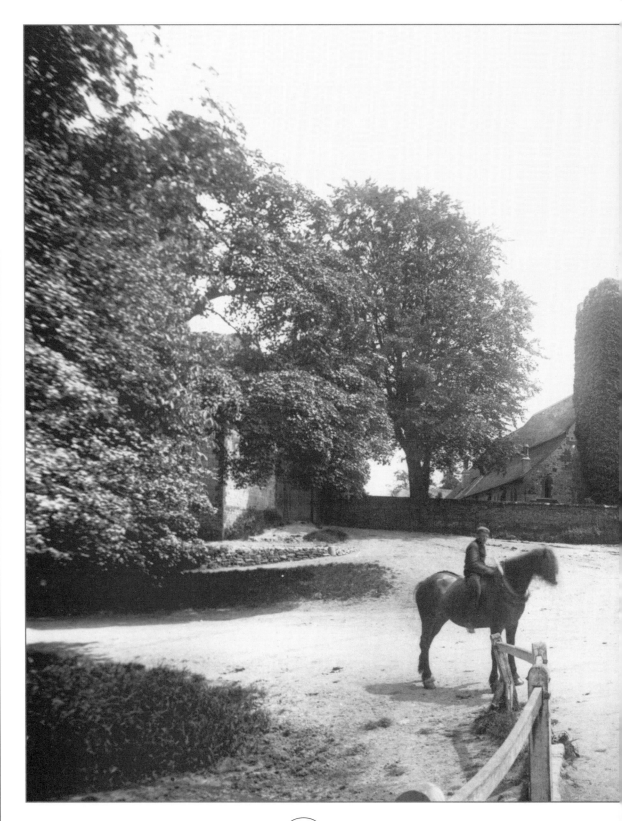

Buriton, The Church of St Mary 1898 41369
The creeper-covered tower peeps between the trees in this Victorian photograph. In one of the windows are the arms of the Goodyer family - a crest of a partridge holding a good ear of wheat in its beak. John Goodyer was a pioneering botanist whose reputation was so high that he was afforded special protection during the Civil War.

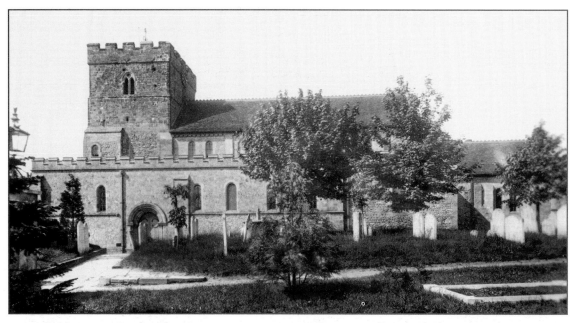

Petersfield, St Peter's Church 1898 41317
Petersfield's restored parish church dates from the 12th century. It is located near the town centre statue of William III, depicted on horseback and dressed, absurdly, as a Roman. One of the headstones in the churchyard is in memory of John Small who died in 1826. He was one of the pioneering Hambledon cricketers, and his epitaph reads: 'Praises on Tombs are Trifles Vainly Spent. A man's Good Name is His Own Monument'.

Petersfield St Peter's Church c1955 P48037
The top of the tower is Perpendicular, and so are the north windows. Inside are various notable features, including an outstanding series of Norman arches and some striking 18th-century monuments. Extensive work was carried out on St Peter's in the 19th century. Originally the church boasted a central tower in addition to its western tower.

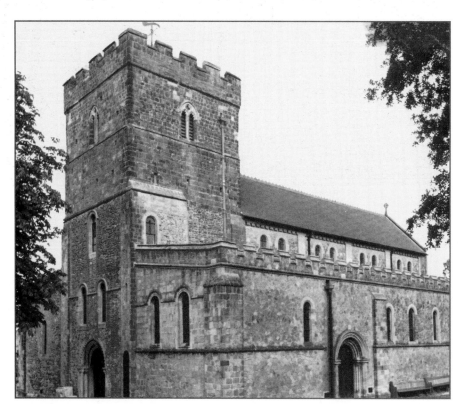

Around Alton

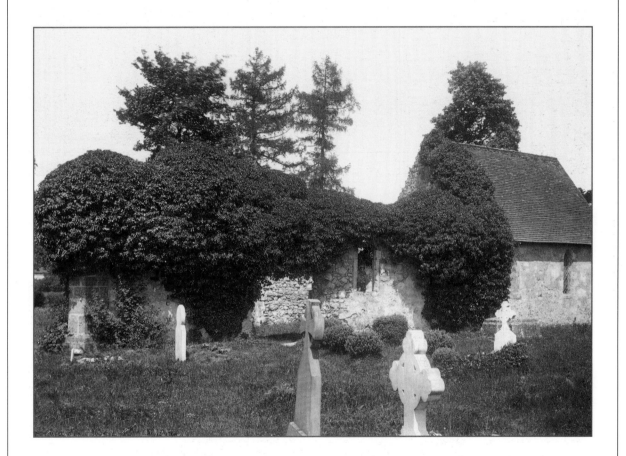

Greatham
The Old Church 1901 46618
The sad ruins of the old village church are shrouded in foliage in this turn-of-the-century photograph.
The writer and historian Arthur Mee mentions the state of the church in his famous book 'Hampshire
with the Isle of Wight'. 'The broken walls of the nave were richly clothed in nature's green when we
called, as if to heal their wounds', he writes. Greatham's more modern church lies across the road.

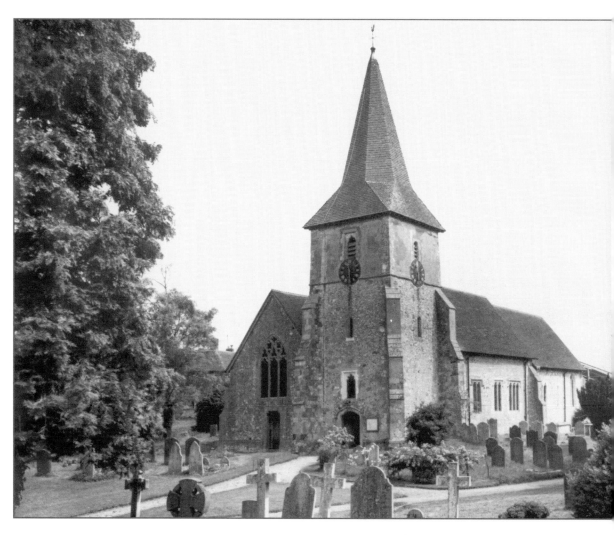

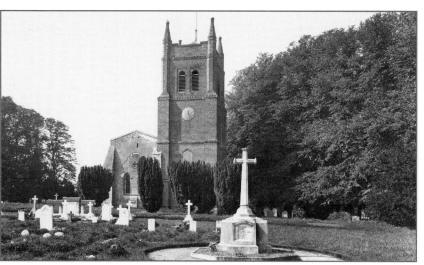

◄ **Crondall, All Saints Church 1930** 83436
The curtain of trees to the right of the church is almost as high as the tower. The church is large, and includes three Norman doorways and a sweeping horseshoe arch. The pinnacled 17th-century tower was modelled on the tower of Battersea church in London. Crondall's church accounts mention the fourpences paid for ferrying masons across the Thames in order to study the model.

◄ **Holybourne
Holy Rood Church
c1960** H104008
The grass is neatly
manicured and the trees
are in leaf. A small spire
rises above the Norman
tower, and five
delicately-carved stone
heads have supported
the nave roof for more
than 700 years. The
windows are decorated
with the striking figures
of Justice, Charity and
Mercy.

▼ **Crondall, All Saints Church
c1950** C194009
Among the church's more
unusual features are the huge
buttresses flanking the west
door. There is another pair of
them south and north, and they
are so large that aisles were
built between them with
windows in the buttresses
themselves. At one time there
was a Church House at the
entrance to the churchyard, but
it later became derelict and was
finally demolished in 1878.

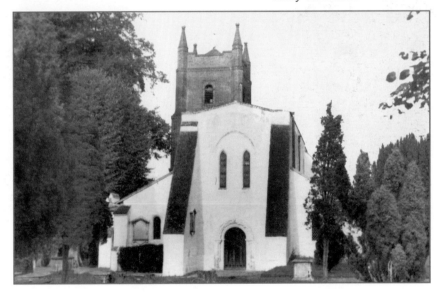

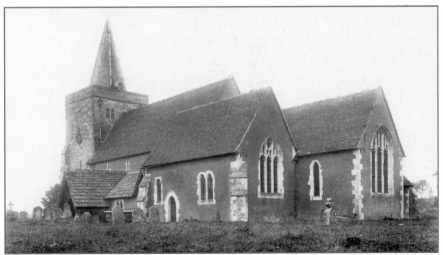

◄ **Binsted
Holy Cross Church
1907** 57253
One of Lord Kitchener's
ancestors lies in the
churchyard at Binstead.
The sleeping knight is
thought to be Sir Richard
de Westcote, who
established a chantry
here in 1332. The
building is unusually long
and large for a village
church; the arches in
the chancel are Norman,
and the tower is more
recent.

Yateley, The Village and St Peter's Church 1906 57007
This classic village scene has changed a bit since this photograph was taken, but the church remains the same, standing guard over Yateley. The tower is supported by sturdy 15th-century beams; the clock, similar to the one in the Curfew Tower at Windsor, was made in Cromwell's time. The lychgate dates back over 300 years.

▼ Yateley, St Peter's Church c1950 Y6008

Visit the church at Yateley, and have a look at the glass in the 13th-century east window: it depicts Peter and John, and is the work of William Morris and the Pre-Raphaelite artist Sir Edward Burne-Jones. The chancel and nave walls are more than 700 years old, and the nave arches were fashioned out of chalk from nearby Odiham.

▼ Bentley, St Mary's Church 1929 82440

The low tower of Bentley church can just be seen against a curtain of trees in this photograph. The base of the tower is over 500 years old, while the top is more recent. Yew trees lead to the church door, and inside is a Norman font with an arcaded bowl resting on four pillars.

▲ Newton Valence St Mary's Church 1907

57249

The Early English church was restored in 1871. As well as the 700-year-old font, have a look at the 13th-century piscina in the side chapel. The magnificent yew standing in the churchyard is about seven yards in circumference. The 18th-century naturalist Gilbert White was curate here.

▼ **Froxfield, St Peter on the Green Church c1960** F188001

Built on the site of an old medieval church which was demolished in 1862, this late 19th-century church is small, with a rather prominent bell turret. On the left of the church path is an 18th-century gravestone with two cherubs blowing the last trump.

▼ **Odiham, All Saints Church 1903** 49202

The largest church in north Hampshire was originally Norman, though it has become predominantly 14th-century. The impressive pulpit carved with scrolls and vases of flowers is worthy of note. The church also includes a 17th-century gallery staircase, a 13th-century chalk font and a 17th-century red brick tower.

◀ **Odiham**
All Saints Church 1924
75281
The church contains many brasses of men and women who lived in the 15th and 16th centuries; the chancel has delicate 15th-century screens, Jacobean altar rails and low arcades dating back to the 13th century. The pillar piscina is about 700 years old. The red and white pinnacles of the tower, just visible in the picture, remind one of the tower of a Tudor house.

▼ **Greywell, The Church of St Mary the Virgin 1904** 51319

Prettily situated among trees and fields, the church of St Mary the Virgin is small but contains many treasures, including a silver chalice dating back to Elizabethan times, a 500-year-old font and a rood loft that survived the Reformation. The church is noted for keeping five of its consecration crosses. Nearby runs the picturesque Basingstoke Canal.

▼ **South Warnborough, St Andrews Church c1955** S634031

South Warnborough's old church has something in common with the church of St Mary the Virgin at Greywell. Both of them managed to preserve their roodloft, unlike most of Hampshire's churches, which lost them during the Reformation. The church has a bell turret and two windows containing Tudor glass. The 13th-century chancel is filled with tombs of over 25 members of the White family.

▲ **Eversley**
St Mary's Church and the Lychgate 1901
46838
There is a tangible air of mystery about Eversley church. Inside, among other fascinating features, is a sarsen stone hidden beneath a trap door. The stone, discovered in 1940, could be part of the foundations of a heathen place of worship. The Victorian author Charles Kingsley, who wrote 'The Water Babies', was rector here for many years.

◄ **Eversley
St Mary's Church 1901**
46841
A few yards from the door of Eversley church lies the grave of Charles Kingsley, who was buried here 26 years before this photograph was taken. His wife Fanny lies with him. Above the grave is a striking white marble cross with the words 'God is love' inscribed on it. The foliage is not so thick today, and neat paths and manicured lawns surround the church.

Hartley Wespall, St Mary's Church c1960 H370004
Set amidst some trees, their branches bare in this winter photograph, Hartley Wespall has a high-pitched roof supported by moulded timber pillars from trees felled 800 years ago. The fine old pulpit is Jacobean, and there is a striking screen crowned by a crucifix. On one of the walls is a memorial to two brothers, both captains, killed in the war. One of them won the DSO.

Farringdon, All Saints Church 1907 57247
The church is famous for its association with the naturalist Gilbert White. He was curate here at one time, and used to preach in summer from the steps of a stone cross in the churchyard. Nearby is a large, redbrick building with towers, gables and terracotta panels. Massey's Folly, as it is known, was constructed by the eccentric Reverend Massey, a vicar of Farringdon between 1857 and 1919.

Medstead
St Andrew's Church c1955 M324015
Stand just inside the door of this old 11th-century church, and you
can hear the soothing tick of the clock above you. Look out for the
beautifully-crafted baptismal roll near the font, which records
children baptised here between 1986 and 1991. Near it is a
memorial tablet to a local woman who worshipped at this church
for 47 years. The organ was installed in 1883, and the bells were
rehung in 1966. The tower and the vestry were a convenient
hiding place for smuggled contraband at one time, as few, if any,
people visited the church during the week.

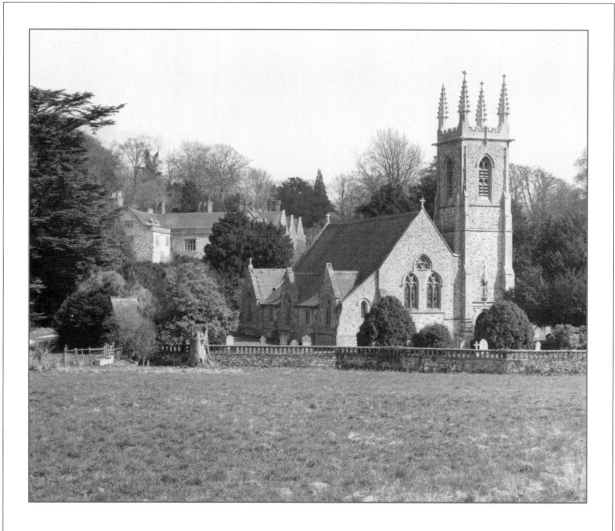

Chawton
St Nicholas's Church c1965 C530123

A church has stood on this site since the 13th century. A disastrous fire in 1871 destroyed much of the building, and only the chancel and sanctuary survived. The nave, north aisle, vestry and tower date from the late 19th century. St Nicholas's Church is probably best known for its association with Jane Austen and her family. Follow the signs in the churchyard and you will find the graves of Jane's mother and sister, both of whom were named Cassandra. Nearby, through a little lychgate, you can see the graves of three family pets who were buried here in the early part of the 20th century. John Hinton, who was rector here for 58 years, is commemorated inside the church, and there are memorials to the Knight and Bradford families. Jane's brother Edward inherited the Chawton estate and took the name Knight.

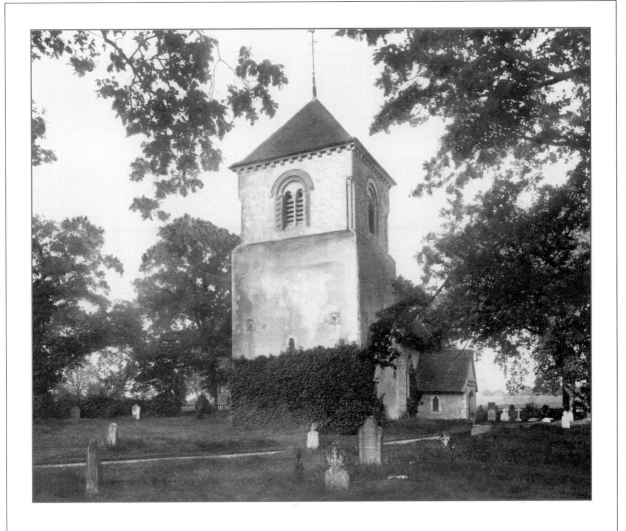

Winchfield
The Church of St Mary the Virgin 1904 51238
This delightful little Norman church is known in the
area for its red roof and red-capped tower. Its superb
Norman doorway has richly carved sides and arches
and distinctive fern leaves round its capitals. The
churchyard is pleasantly sheltered by trees.

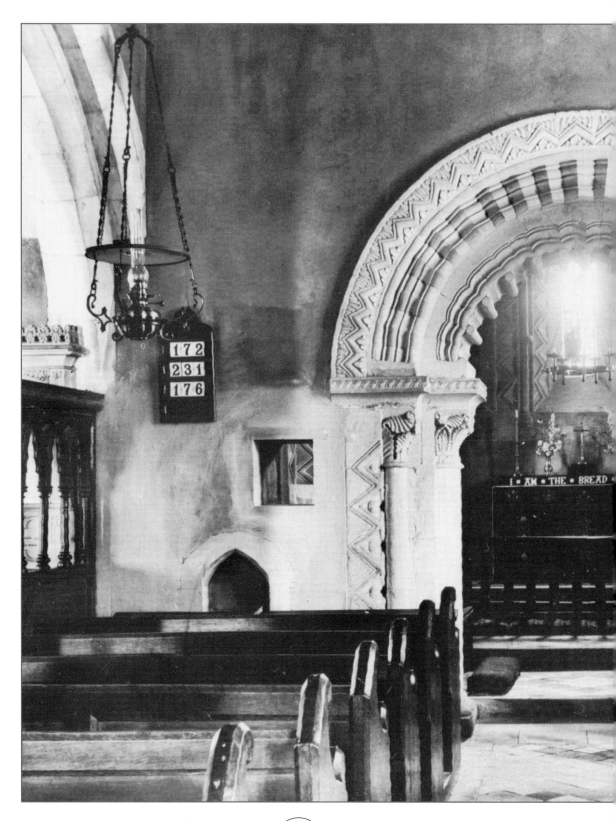

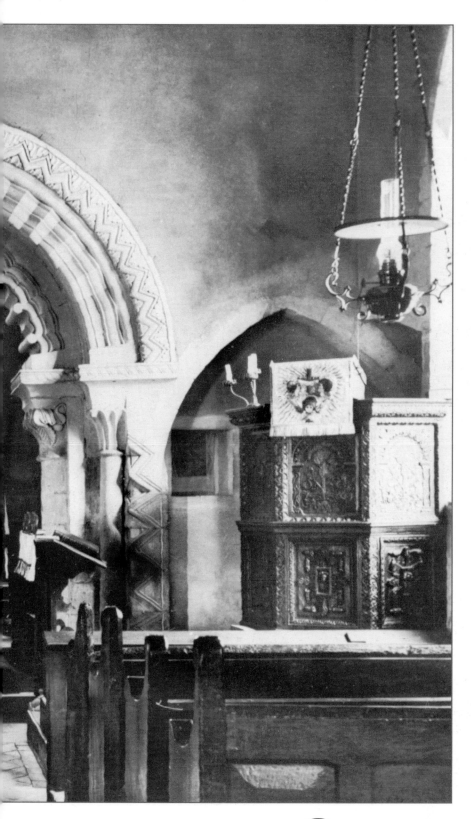

**Winchfield
The Church of St
Mary the Virgin
Interior 1908** 60084
The elaborately
decorated Norman arch
leads into a chancel
illuminated by narrow
windows decorated
round the edges with
zig-zag carving. The
chancel is so small that
there is only room for
two small benches. To
the right is the striking
17th-century pulpit,
richly carved with
cherubs and vases of
flowers.

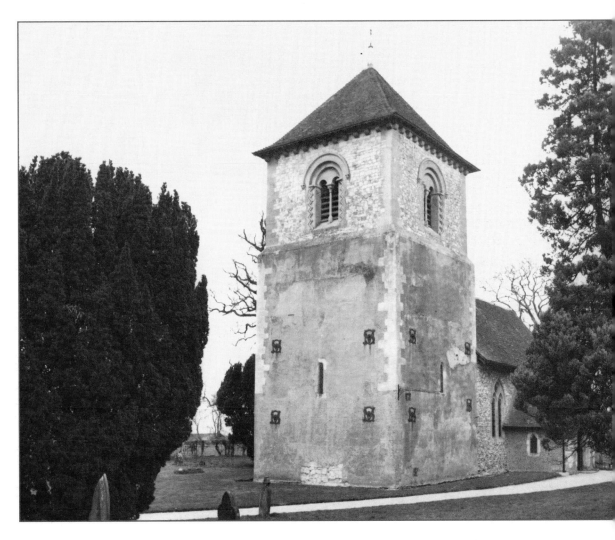

◄ **Alton, All Saints Church c1955** A39022
Standing on the corner of the High Street and
Queens Road is All Saints' Parish Church.
To the right of the main door is a plaque in
memory of James Drummond Carter, who was
vicar of this church between 1912 and 1917.
Alton is famous for its Pilgrims' Way setting,
commemorated by a plaque at the main
entrance.

◄ Winchfield, The Church of St Mary the Virgin c1960 W108062

Inside the church is a Norman font, with pillars of Purbeck marble at its base. Behind it is a plain Norman tower arch. On the walls are the initials of the church, seen at regular intervals round St Mary's. Regular worshippers will tell you there is an ancient oak pew in front of the pulpit, possibly dating back over 700 years.

▼ Liss, St Peter's Church c1955 L54021

The tree-sheltered tower of St Peter's stands guard over a church that is the work of 13th- and 15th-century builders. The delightful south doorway and parts of the tower are 13th-century. Inside, the pointed arches of the nave arcade, the traceried window in the north wall and the font are all more than 500 years old.

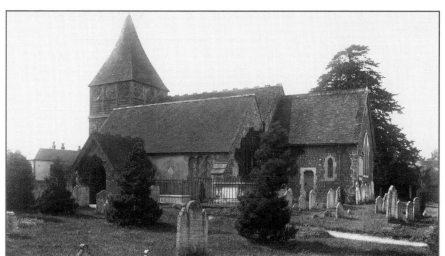

◄ Liss St Peter's Church 1901 46616

Compare this photograph with the more recent picture of St Peter's (L54021), and you can spot a few subtle changes. By the mid-1950s, trees had begun to engulf the church on virtually all sides, whereas in this photograph buildings are still visible nearby.

▼ **Liss, The Church of St Mary the Virgin c1955** L54003
Built by Sir Arthur Blomfield in the last decade of the 19th century, St Mary's is noted for its sizeable tower with rows of square bell openings. Blomfield 'captured a noble grandeur in his design', says Margaret Green in her book 'Hampshire Churches', though Pevsner describes it as 'dignified and dull'.

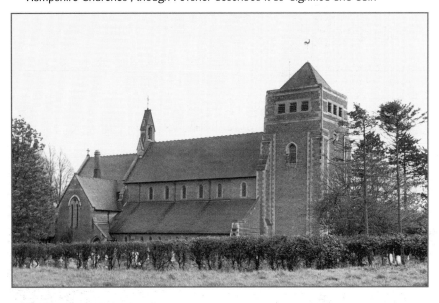

▼ **Grayshott, St Luke's Church and the War Memorial 1928** 81476
St Luke's church was built in the Early English style at the beginning of the 20th century. Its south-east tower has a prominent broached spire. As well as the church, this photograph captures the war memorial, an old village signpost and a quaint street lamp.

▲ **Church Crookham Christ Church c1960**
C102010
Christ Church at Church Crookham dates back to 1841; it lies in an area of Hampshire famous for its strong association with military training. Note the bellcote and the neat, well-tended gravestones. Inside there is extensive incised decoration and figure-work. Two lancet windows contain exquisite angels.

◀ **Farnborough
St Peter's Church 1921**
70030
What seems to dominate this photograph of St Peter's Church is the prominent weatherboarded west tower. The north and south doorways date back to about 1200, and the north porch is Perpendicular. Inside are portraits of St Agnes, St Eugenia and Mary Magdalen; they are thought to be 12th-century, and can be seen on the north wall.

▲ **Cove**
St John's Church
c1955 C172019
Built in 1844,
St John's has a low
crossing tower which
seems to dominate
the picture, almost
giving the impression
that it is out of
proportion to the rest
of the building.

Fleet ▶
All Saints Church
1903 49222A
All Saints Church dates
back to 1861-62 and
cost £3,323 to
construct. Built of red
brick, it has a steep
bellcote over the east
end of the nave. Inside
is a monument to
Charles Lefroy, who built
the church in memory of
his wife. There are
several effigies of the
founders, with two dogs
at their feet.

Hartley Wintney
St Mary's Church c1955 H247037
The old cruciform church, no longer in regular use, has been
replaced by a new one, but St Mary's, noted for its pinnacled
tower, is worth close scrutiny. Dating back to the 12th century, this
secluded church lies down a lane outside the village centre, its
peaceful churchyard lined with trees. Inside is a Norman piscina on
a slender pillar, with a head carved on its basin. The doorway is
over 700 years old, and both the nave and chancel include
14th- and 15th-century work.

**Headley
All Saints Church
and the Rectory 1925**
78223
Close to the Surrey and
Sussex border,
Headley's restored
church dates back over
six centuries and is
distinguished by its
sturdy medieval tower.
Inside are oak pews and
a panel of 13th-century
glass depicting a saint
kneeling for execution.
Also on display are
brasses of an unknown
couple.

▲ **Upper Froyle
St Mary of the
Assumption Church
1907** 57257
Overlooking Froyle
Place is the pinnacled
red-brick tower of
Froyle's church. Much
of the building is
18th- and 19th-century
and built of stone.
The chancel and east
window, which has
original armorial
glazing, date back to
the 14th century. The
large chancel, which
is almost as long as
the nave, contains
a piscina.

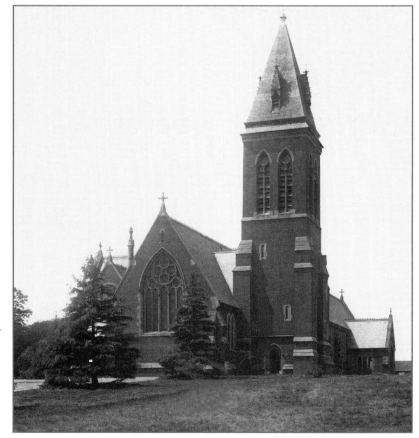

**Aldershot, All Saints ▶
Church 1891** 28671A
Built of brick in 1863, All
Saints is distinguished by
its bar tracery and by its
prominent north-east
tower, which has a steep
pyramidal roof.

Around Basingstoke

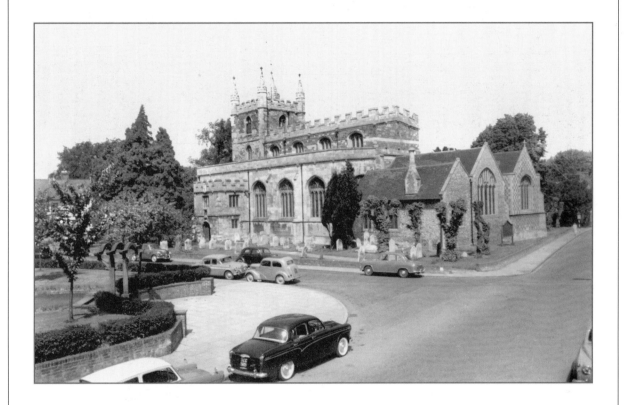

Basingstoke
St Michael the Archangel's Church c1960 B31042
The town's 16th-century church of St Michael the Archangel can be seen from
various vantage points around Basingstoke; it is perhaps the finest of Hampshire's
Perpendicular parish churches. Look closely, and you can spot a room over its
porch. Inside are the Royal Arms of Elizabeth, James I and William III.

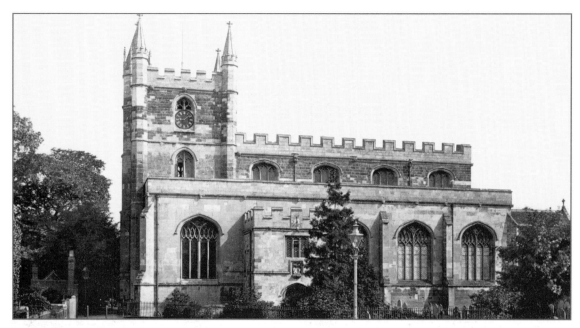

Basingstoke, St Michael the Archangel's Church 1898 42053

The south aisle was badly destroyed by fire just before the Second World War, and the then vicar sat in the damaged church to receive contributions for the rebuilding work. Some of the early 16th-century glass in the south aisle and the south chapel originally came from the old Chapel of the Holy Ghost, which can be found in a cemetery near the station.

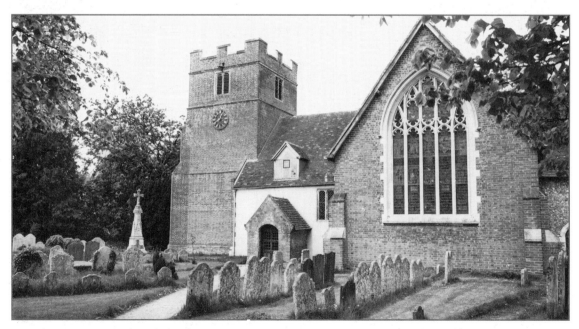

Bramley, St James's Church c1960 B696030

The late Norman church, distinguished by its red crenellated tower, contains some ancient wall paintings, including a fresco of the murder of Thomas a Becket. Also on display are stained glass and brasses. One of the church's greatest treasures is a chapel dedicated to the memory of the Brocas family, who lived at nearby Beaurepaire House. The large south window of the chapel is filled with 16th-century glass and is the work of Flemish craftsmen.

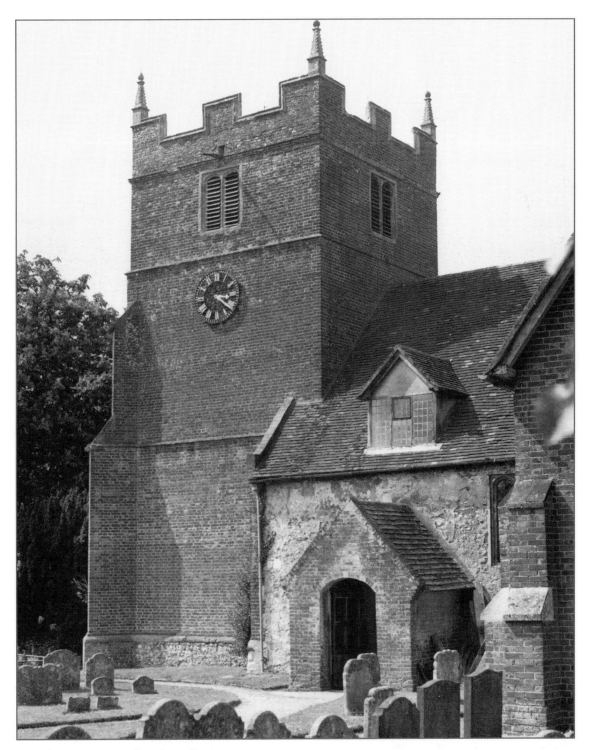

Bramley, St James's Church c1960 B696003
The 19th-century writer Mary Russell Mitford, who lived nearby on the Hampshire/Berkshire border, knew
Bramley and wrote: 'the church is small, simple, decaying, almost ruinous'. In those days the village itself would
have been a sleepy, undiscovered hamlet, with poor roads and a distinct lack of rural services.

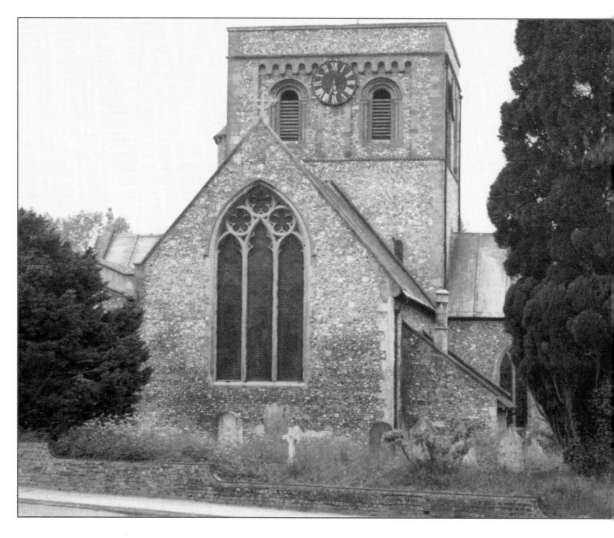

◁ **Tadley**
St Mary's Church
c1965 T283014
This modern parish church was built in the early 1960s to serve the north Tadley area, populated in those days mainly by MOD employees who worked at the Automatic Weapons Research Establishment in nearby Aldermaston, a former RAF station. AWRE moved here from Woolwich after the Second World War.

◄ Kingsclere, St Mary's Church c1955 K140035

This Norman church was heavily restored in 1848-9, though the north doorway is original. It was once paved with medieval tiles, and later the walls were hung with them. The chapel, on the south side, contains magnificent monuments to Sir Henry Kingsmill and his wife Lady Bridget. Sir Henry held the manor of nearby Sydmonton until his death in 1625, and it was his widow who was responsible for the splendid marble and alabaster tomb.

▼ Oakley, St Leonard's Church c1960 O111027

The pinnacled tower of Oakley church has a sturdy staircase turret, a fine Tudor doorway, and a memorial window to William Warham, a local boy, reputedly born at nearby Malshanger House, who became Lord Chancellor and Archbishop of Canterbury. The window shows him dressed in brown and golden robes with one of his hands holding a cross and the other raised in blessing.

◄ Overton, St Mary's Church c1955 040019

Seventy-five years ago, Overton's church tower was flat; nowadays its spire looks out over the River Test which rises close by. The church has 13th-century walls, 14th-century arches supported by Norman piers and a fascinating old door.

Overton, St Mary's Church c1960 040014
The church has long been associated with a man by the name of John Bentley, who fled here after accidentally killing a man. The angry worshippers dragged him out and took him to Winchester to face trial. However, William of Wykeham, Bishop of Winchester, considered that the villagers had violated the man's ancient right of sanctuary, and ordered an inquiry.

Silchester, St Mary the Virgin's Church c1965 S632032
The church stands on the site of an important regional Roman town known as Calleva Atrebatum. Little is known about the early history of the town, though the amphitheatre and public baths probably date from around AD 70 or 80. The church stands within the sacred pagan enclosure of the old town, and was built between the 13th and 15th centuries. The chancel, with its priest's doorway and wall paintings, is early 13th-century and the fine chancel screen dates from around 1500.

Sherfield-on-Loddon
St Leonard's Church c1965 S631026
Alexander Pope, who spent his childhood in this part of the world, wrote: 'Loddon slow, with verdant alders crowned'. He was referring to the river which flows through the village on its way to meet the Thames. The spired 19th-century church has a prominent tower; it occupies a pleasant, peaceful setting outside Sherfield-on-Loddon.

Whitchurch, All Hallows Church c1960 W490030
The parish church of All Hallows on the west side of the town has some interesting features, including an Anglo-Saxon memorial stone to a woman who it is believed was a nun from nearby Wherwell Priory. The Latin inscription reads: 'Here lies the body of Frithburga, buried in peace'. For many years bellringers at the church used the stone to stand on. The pediment clock which tops nearby Whitchurch silk mill chimes throughout the day and night, and occasionally plays a duet with the bell ringers at All Hallows.

Longparish
St Nicholas's Church 1899 43700
The church tower at Longparish is over 500 years old, though the nave arcades
with their scalloped capitals are even older. The south doorway is 14th-century;
the pulpit has an old hourglass, and the font boasts a distinctive pinnacled cover
about ten feet high. Look out for the Bethlehem east window in the chancel.

St Mary Bourne, The Village Street and St Peter's Church c1955 S635017
St Peter's boasts a truly extraordinary feature - a huge font made from black Tournai marble and carved eight centuries ago when the church was built. Its four sides are about fourteen feet round. There are very few fonts of this kind in this country, and this is certainly the largest. The stone effigy of an armoured knight is thought to be the crusader Sir Roger de Andelys. The Norman chancel arch has a band of beaded moulding.

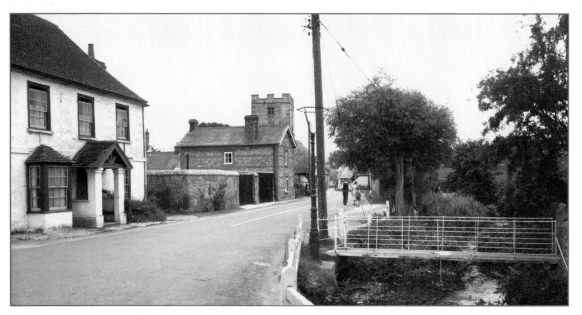

St Mary Bourne, The Village and St Peter's Church c1955 S635013
The church is associated with an amusing if somewhat irreverent story concerning a former rector of St Mary Bourne. It was his wish that the coffin in which he was buried should be made from a tree in the garden of the rectory. It was also his desire that when he died his collection of books be buried with him in the coffin. However, such was the size of the collection when he eventually died, that when it came to sealing the coffin, its lid could not be closed!

Monxton
St Mary's Church 1888 42090
Monxton Church is still associated with the Reverend Thomas Rothwell, a somewhat eccentric rector who presided over this parish during the 18th century. Many clergymen developed manias or obsessions for a whole host of subjects - astronomy, literature and science among them. In the case of Thomas Rothwell, it was mathematics and algebra. It is said that he took no interest in anything else, never leaving the house to carry out his duties in the church, nor even giving himself time to be shaved. His eventual death was the result of an illness brought on by neglect. A curate would probably have taken on his clerical duties.

Abbots Ann
St Mary's Church c1955 A4015
The church has a strong Georgian feel to it. It is well-known for the
medieval funeral custom of awarding a virgin's crown. The
ceremony takes place at the funeral of any unmarried person of
unblemished character who was born and baptised in the parish
and who died here too. The crowns are made of hazelwood and
are suspended from the gallery for about three weeks, so that all
who enter the church must pass beneath. If no-one disputes the
deceased's good name in that time, the crown is taken down and
hung on the wall either side of the nave until it falls down through
old age. Few parishes uphold the tradition today. The church is also
noted for its panelled box pews.

Abbotts Ann, St Mary's Church 1899 43696
The church was rebuilt in 1716 by Thomas Pitt, an enterprising businessman who made a great deal of money by selling a valuable diamond at a huge profit. Known as 'Diamond' Pitt, Thomas was the grandfather of William Pitt the Elder. The church stands in the shadow of several yews and chestnuts. Inside are delicately embroidered kneelers.

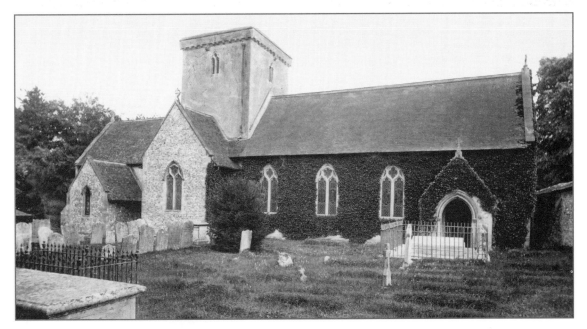

Amport, St Mary's Church 1898 42091
Substantially altered in the 19th century, this 14th-century church recalls the names of the family of the Marquess of Winchester, including many admirals and generals. One of them was William Paulet, one of the commanders in the Crimean War. The church, which is adorned with flags and swords, also includes a portrait medallion of the 15th marquess, who died in battle in South Africa.

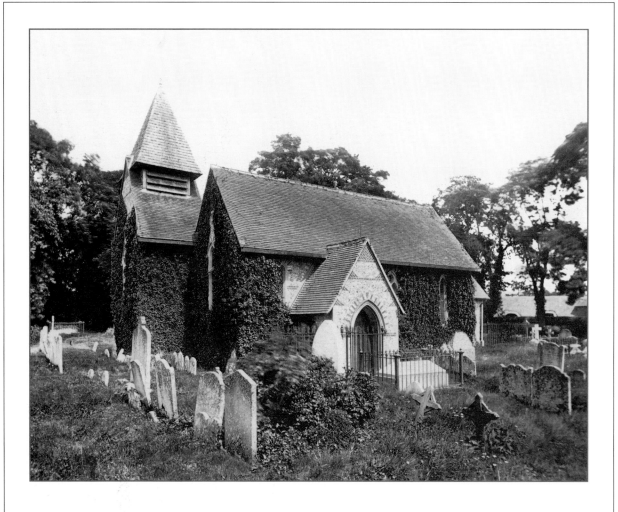

Weyhill
St Michael and All Angels Church 1898 42087
Close to the county boundary with Wiltshire, Weyhill's small church
was restored in the 19th century but retained its early Norman
chancel arch and an ancient bell. There is also a silver chalice with
Elizabethan engraving. The churchyard, which includes a cross
brought from Jerusalem, looks overgrown and neglected at this time.

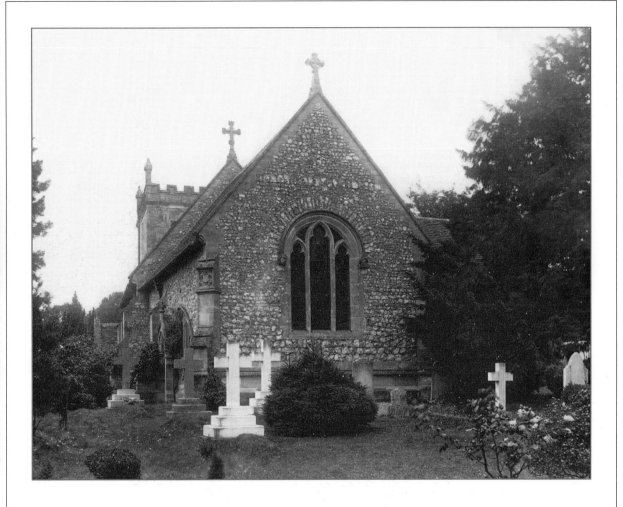

Thruxton
The Church of St Peter and St Paul 1898 42089
The tower of this 13th-century church contains a brass to
Sir John Lisle, a knight who died just after Agincourt, as
well as a wooden effigy carved in English oak and thought
to be of Elizabeth Philpotts, lady of the manor. The church
also records a list of rectors from 1243 onwards.

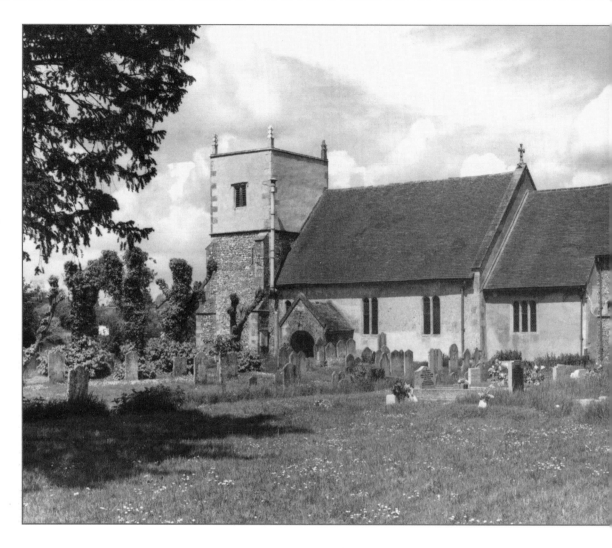

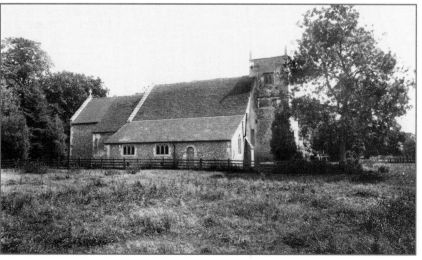

◀ **Upper Clatford
All Saints Church
1899** 43694
The unusual Norman arcade between the nave and the chancel resembles a double chancel arch or two broad chancel arches side by side. The pillar piscina with a carved front dates from 1200, and the church also boasts a pewter alms dish. The church has some 17th-century additions.

Upper Clatford
All Saints Church c1965
U53026

Delightfully situated in a meadow near the River Anton, this little church with its pinnacled tower dates from different periods. The brick porch is 18th-century, and the tower is 16th-century. There is also a blocked doorway which is 12th-century, while the font and the striking canopied pulpit are both 17th-century.

Goodworth Clatford
St Peter's Church 1965
G87006

Located in a lovely corner of Hampshire, close to the rivers Anton and Test, and near the sprawling woodland of the Harewood Forest, this church includes two 14th-century arcades, one of which bears two strange faces on a pillar, while the other has Norman piers and 13th-century arches resting on them. The nave has a kingpost roof of dark beams, and the font is Norman.

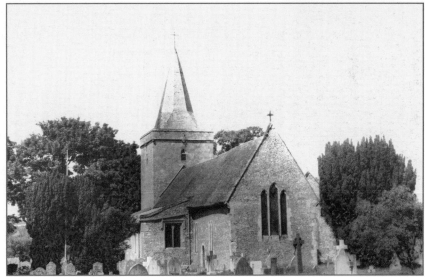

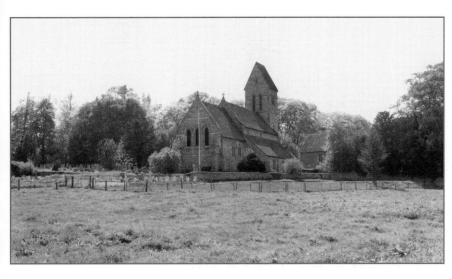

Over Wallop
St Peter's Church
c1965 O98025

Near the Wiltshire border, St Peter's contains a tablet which recalls a chorister's dedicated service in this church. He sang in the choir here for 64 years. St Peter's dates from the 12th and 13th centuries, and includes a piscina and an Easter sepulchre. The chancel screen and pulpit are made of wrought iron.

◀ **Wherwell
The Church of St Peter and
Holy Cross 1901** 46355
One hundred years after this
photograph was taken, the village
of Wherwell remains much as it
was at the start of the 20th
century. So, indeed, does the
church. Rebuilt in the 19th
century, it contains part of an
ancient Saxon cross and some
fascinating pieces of 13th-century
sculpture. The sleeping figure is
thought to be a nun who was
prioress here in the 14th century.

Nether Wallop, St Andrews Church c1965 N156017

Wallop means 'valley of the stream'. The medieval church stands not far from the famous airfield at Middle Wallop, which was a Battle of Britain fighter station. During the Second World War the skies above the church would have echoed to the unmistakable sound of Spitfires and Hurricanes. Inside are ancient pews, sculptured capitals in the nave and Tudor timbers in the roof. Medieval paintings, depicting St George fighting the dragon, were uncovered on the church walls by experts from the Royal College of Art.

Andover, General View with St Mary's Church 1899 43689

Just visible on the right of the picture is Andover's 19th-century church of St Mary, built in the Early English style by a former headmaster of Winchester College and described as the best Victorian church in Hampshire. One writer commented in 1908: 'little else than tradition remains of old Andover'.

South Tidworth The Garrison Church of St Michael c1955

S633005

Built by Douglas Hoyland in 1912, this terracotta building to the west of Andover has Perpendicular-style windows and a bell turret over the crossing.

Around Winchester

Weeke
St Matthew's Parish Church c1965 W487001
Close to the centre of the ancient city of
Winchester, this tiny manor church stands in the
shadow of a towering cedar tree. Inside is a brass
of William Compton, one of St Matthew's most
significant benefactors. The partially-concealed
doorway is Norman, and in the 13th-century
chancel is a small stone in memory of
Dr Harpesfield, who was rector here at the time
of the Reformation.

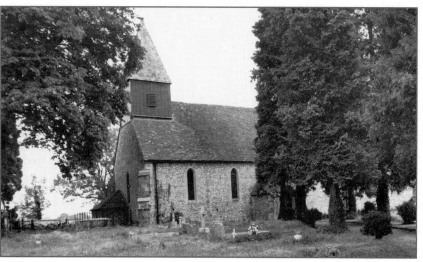

◄ **Exton, The Church of St Peter and St Paul c1955** E221016
One of Exton church's more unusual features is a headstone which depicts the Angel of Death summoning a book lover, who sits up in bed to face his final visitor. The church contains a delightful Jacobean altar, a 13th-century canopied piscina and a Victorian Early English-style font.

Waltham Chase, Shedfield St John the Baptist Church c1950 W484017

Close to the small Hampshire town of Wickham lies the village of Shedfield. Here you will find a late-19th century church faced with stone and distinguished by its sturdy pinnacled tower. The inside of the church is decorated with multi-coloured brick, some of which is moulded.

▼ Corhampton The Saxon Church c1960 C575001

One of Hampshire's hidden treasures, this lovely Saxon church lies near the River Meon and has changed little over the years. The sundial on the south wall is divided not into 12 sections, as is usual today, but eight three-hour 'tides', representing the Saxon way of counting time. The wall-paintings in the chancel are among the most important in the county and probably date from the 12th century.

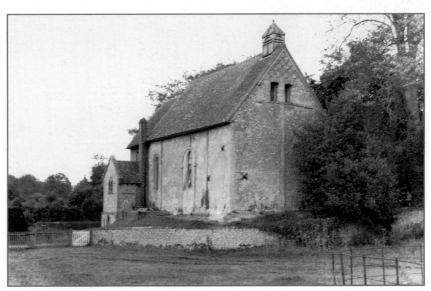

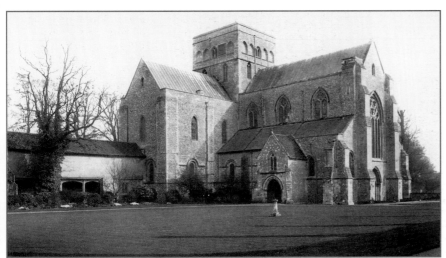

◄ Winchester St Cross Church 1896 37250

The splendid church of St Cross was built between 1170 and 1230 for the poor brethren, and is a fine architectural mix of Norman and Early English. The squat tower is thought to have been rebuilt in 1384. Inside, there is a striking Norman font and a lectern of 1509.

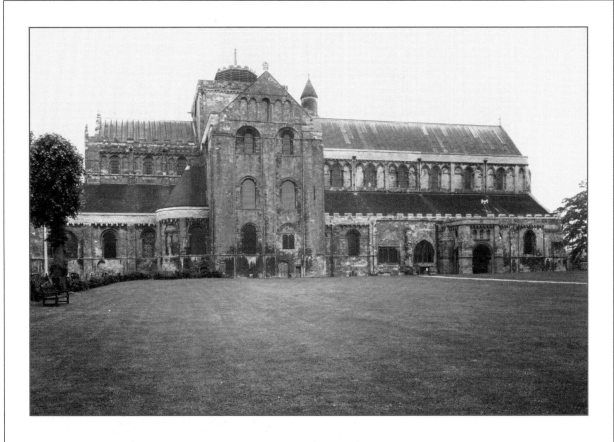

Romsey
The Abbey c1960 R53034

The great Norman church is one of the most impressive in Europe, and certainly the finest in Hampshire. The Abbey was founded in AD 907 by Edward the Elder, son of Alfred the Great, but the main part of the building was built in the 12th century by Henry de Blois, Bishop of Winchester. Originally an Anglo-Saxon church stood on this site, and the remains can be seen behind the choir screen. Until the mid 16th century, Romsey Abbey was home to a Benedictine order of nuns; it is believed Edward's daughter may have been the first Abbess at Romsey, for she is buried here. At the time of the Dissolution, the Abbey was saved from destruction and sold to the people of Romsey for £100, whereupon it became the town's parish church.

Stockbridge
St Peter's Church c1965 S259099

St Peter's was built in 1865-66 to replace an earlier church. During its construction, the people of Stockbridge worshipped in the Town Hall. St Peter's retains some interesting features from the old church: there are some 14th-century windows worthy of note, for example. The church tower has six bells, four of which are from the original St Peter's. The Lady Chapel has a stone cross on the altar depicting a simple figure of Christ. It was discovered walled up in a part of the old church when repairs were carried out early in the 20th century. The original church was rehallowed in 1963 and became a mortuary chapel.

Houghton, All Saints Church ▶
1904 51452
The peaceful village of Houghton lies close to Stockbridge on the banks of the Test, famous for its exclusive fishing club. The 12th-century broach-spired church contains piscinas, consecration crosses and squints, and the piers and capitals here date from the 12th century.

▼ **Hambledon**
The Village and The Church
of St Peter and St Paul c1955
H405001
The church is built in various architectural styles, and is often regarded as a textbook example of how an English parish church has been extended and altered between Saxon and medieval times. You can see evidence of Saxon work in the walls of the nave, as well as the delicate sculpture of four Norman arches. The tower looks down over the attractive village with its timber-framed cottages and Georgian houses.

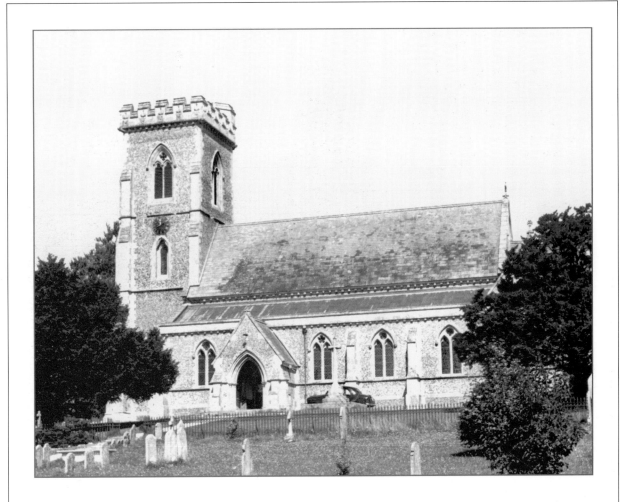

West Meon
The Church of St John the Evangelist c1965 W488036
This flint church was the first in Hampshire to be designed by George
Gilbert Scott, who was also responsible for the Albert Memorial and
St Pancras station in London. It contains the graves of two Englishmen
remembered for entirely different reasons. The first is Thomas Lord, founder
of the famous cricket ground in London, who lived near here in his later
years. The other is Guy Burgess, a communist agent who defected to Russia
in the early 1950s. When Burgess died in 1963, his mother requested that
his ashes be returned to Britain for burial. His remains were brought back in
an earthenware pot decorated with Russian script and buried in the family
plot at West Meon. The service was held after dark to avoid reporters.

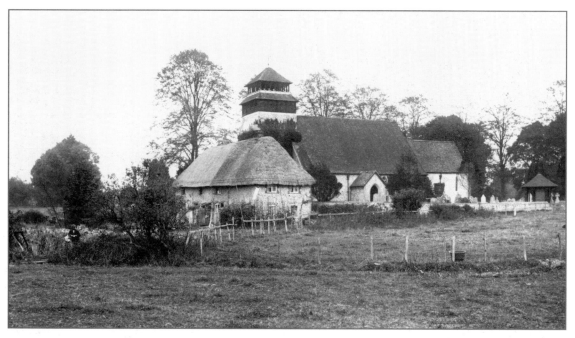

Meonstoke, The Village and St Andrew's Church c1955 M304004
This 13th-century church, which lies beside picturesque thatched cottages, has a handsome 17th-century pulpit with striking twisted columns and wide arm-rests. The sculptured font is Norman, and in the chancel are several stone coffins discovered in the churchyard. The tower is 13th-century.

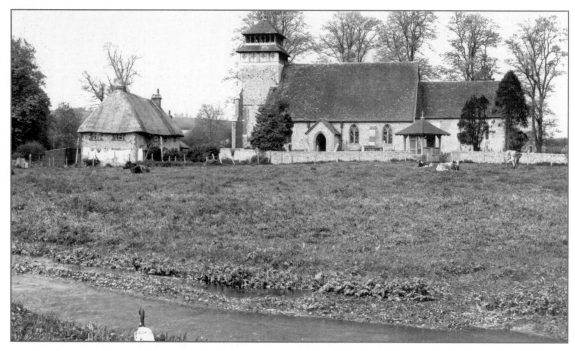

Meonstoke, St Andrew's Church c1955 M304014A
Cattle graze in front of the church, and a duck can be seen by the river in this delightful photograph. It is rare for a church to change its dedication, but it happened in this village. St Mary became St Andrew in 1830.

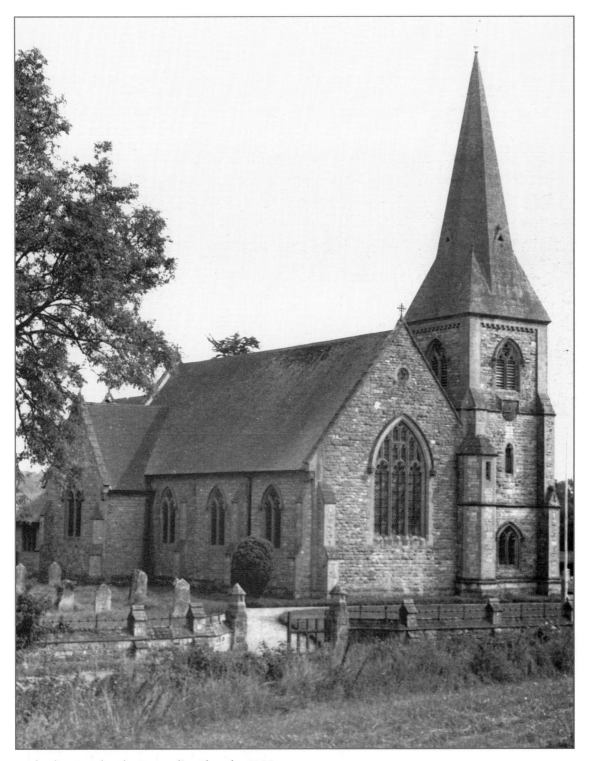

Lockerley, St John the Evangelist Church c1955 L367025
This modern spired church replaces a Norman building. It was built by the owner of Lockerley Hall. The pews are of Kauri-pine from New Zealand. The old church, built on a Saxon foundation, was destroyed in the 19th century.

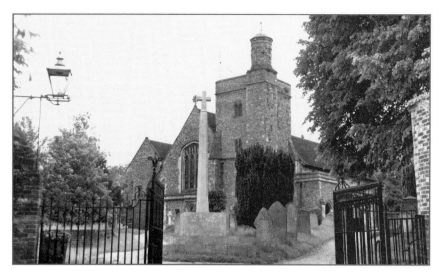

**Bishop's Waltham
The Church
of St Peter c1955**
B612001
This flint and stone
church has been
extensively restored over
the centuries. Its most
eye-catching feature is
the early 17th-century
tower, which is large and
squat with Tudor-style
windows. Rising above
it is the staircase turret.

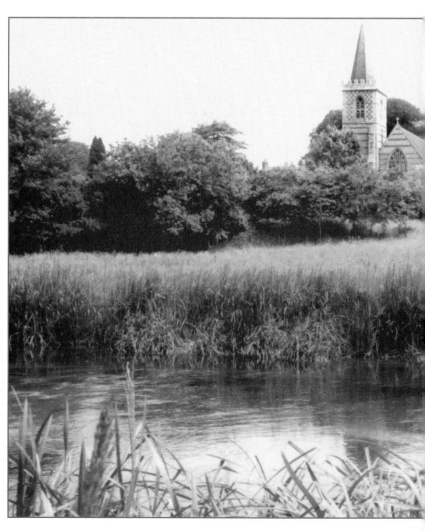

Twyford, St Mary's Church ▶
**from the River Itchen
c1965** T284032
This photograph captures an
idyllic scene. With its modern
tower and spire rising 140
feet above Twyford, the
handsome church looks out
across woods and meadows
towards the bank of the
Itchen. Some interior features
are very old; for example, the
font and arcades on each side
of the nave date from 1200.

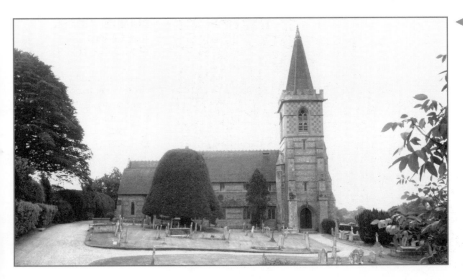

Twyford, The Parish Church of St Mary c1965 T284028
Twyford Church has long been associated with a man named William Davies. The story, which dates back to the mid 18th century, suggests that Davies lost his way in a fog while making his way home. Fortunately, he heard the church bells, which prevented him from falling into a chalk-pit. As a gesture of gratitude, he bequeathed £1 every year to the bell ringers.

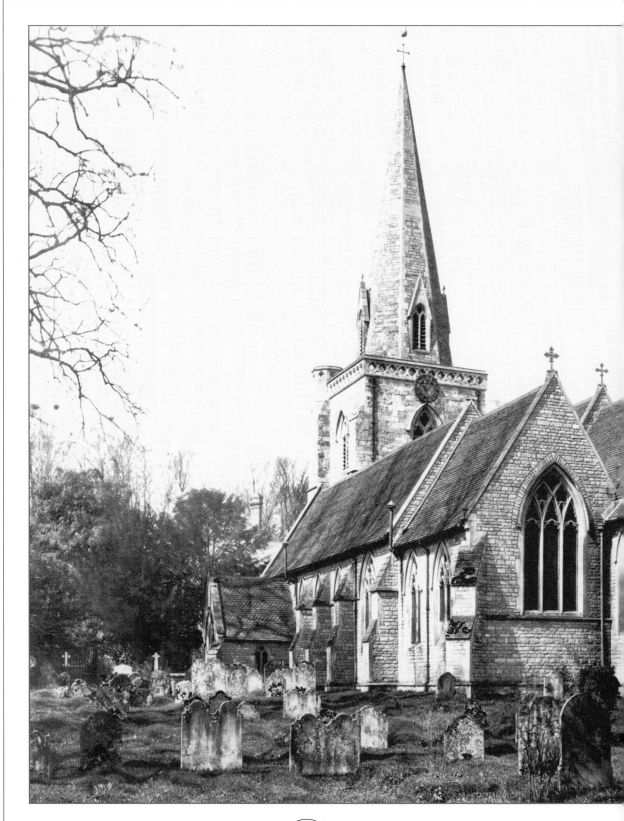

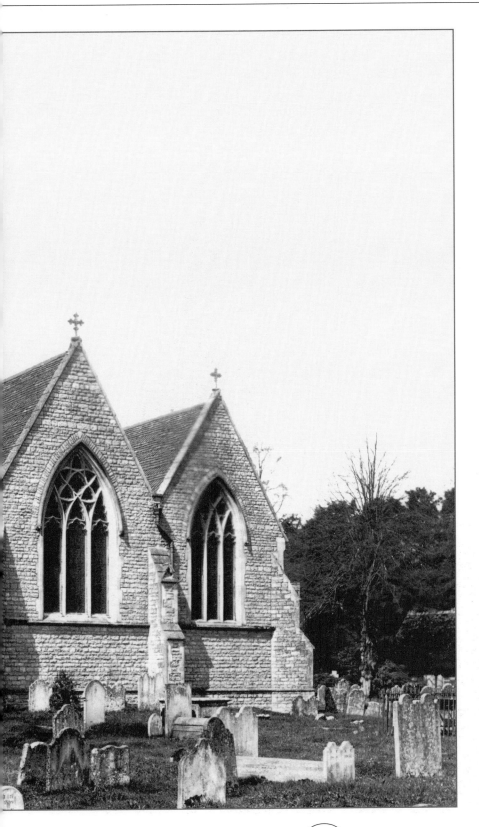

Hursley
All Saints Church
1886 19446

All Saints was built by J P Harrison, a prominent figure in the Oxford Architectural Society, for John Keble, who was vicar here for 30 years between 1836-66. The work cost £6,000, and was paid for by the royalties of Keble's book 'The Christian Year'. Known for its Perpendicular tower, the church contains various memorials, including a brass to John Keble, dated 1866. He and his wife are buried in the churchyard. Oliver Cromwell's son Richard, who lived at Hursley, lies somewhere under the chancel, but the precise location of his grave is not known, as the church has been rebuilt several times over the years.

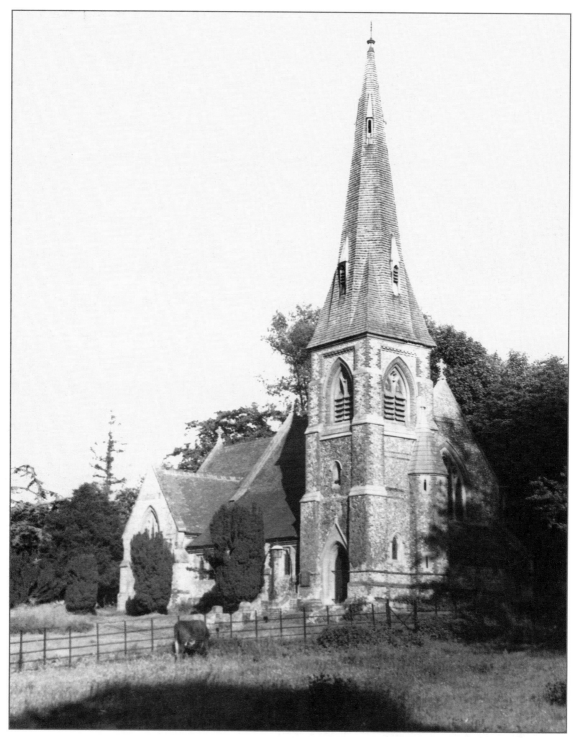

Preston Candover, St Mary the Virgin Church c1955 P166012
The spired church, which has a Saxon stone coffin over its doorway, dates back to the latter part of the 19th century; it replaces the old church, much of which, sad to say, was destroyed by fire. In its day, the old church was presided over by three generations of rectors from the same family - Peter, William and John Waterman.

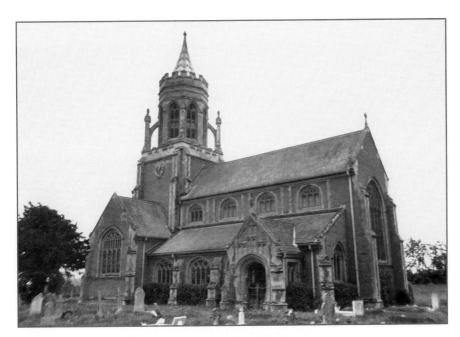

Sherfield English St Leonard's Church c1965

S630018

The spire of St Leonard's Church, on the edge of the New Forest, dates from 1902; it was built for Lady Ashburton, a member of the wealthy Baring banking family, as a memorial to her daughter. It is an exuberant feature of the church, with flying buttresses and pinnacles. But the extravagance does not stop there, for even the windows are decorated with Art Nouveau glass.

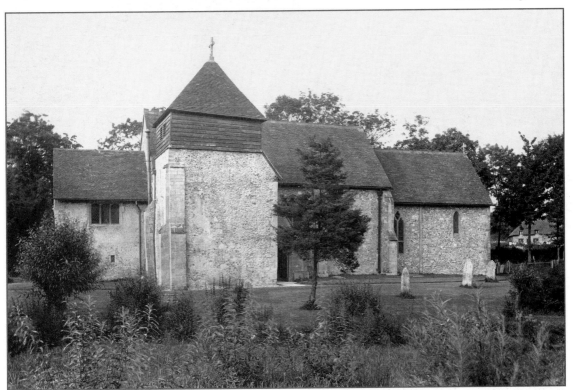

Headbourne Worthy, St Swithun's Church 1912 64464

Restored in 1865-66 and dedicated to St Swithun, the church at Headbourne Worthy is one of the oldest in Hampshire. Much of it predates the Norman Conquest. The church is noted for its rood screen, carved on what had been an outside wall. However, the figures on it were mutilated when a Bishop of Winchester decreed that crucifixes in churches within the diocese were idolatrous and should be destroyed.

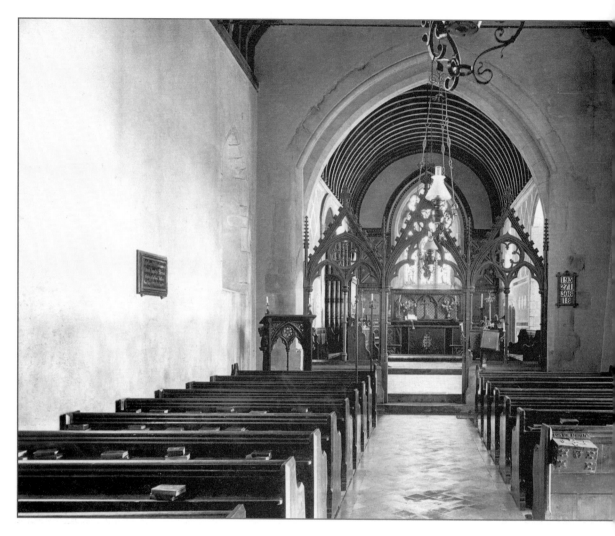

◄ **Brown Candover
St Peter's Church c1960**

B697001

Brown Candover's spired church
was built in 1845
by the first Lord Ashburton,
replacing an earlier place
of worship demolished the
previous year. Inside are relics
from the old church
at Chilton Candover. An impressive
set of altar rails carved with vines
and cherubs by an Italian
craftsman and a large chair carved
with figures of Adam and Eve are
among the treasures.

◄ Headbourne Worthy St Swithun's Church Interior 1912 64465

The Saxon influence remains here, and in the chancel are three ancient stone seats which are thought to be more than 500 years old. The pulpit, seen on the left, has two carved heads either side of it; it is the work of John Henry Slessor, who was rector of this parish for 44 years.

▼ Bishopstoke, The Old Church c1960 B693022

In 1838 the writer Robert Maudie observed: 'the church and the village are beautifully situated, the former close by the bank of the river'. He was referring to the Itchen. This photograph shows the 19th-century tower of the old church, which was not considered strong enough for the bells to be properly rung. However, one bell was chimed every Sunday morning at 8am, even though there was no service at that hour.

◄ Bishopstoke St Mary's Church c1960 B693052

The present church at Bishopstoke was completed in 1891 and contains the bells from the original church. Even though the more modern church drew many worshippers when it opened, some local people feared that the old church would gradually fall into decay. One local resident wrote: 'A good number of Bishopstoke names must now be forgotten, from the closing of the old churchyard and its overgrown and neglected state'.

**Kings Worthy
St Mary's Church
c1960** K143001
In the churchyard is an inscription on one of the headstones in memory of James Parker, who was brutally murdered in 1886. The headstone provides an intriguing clue to the way he died, and will be familiar to some as a quote from the Bible: 'The enemy hath smitten my life down to the ground'. Parker was a young seaman; having just arrived in Southampton, he set off on foot for London with another member of the ship's crew. They called at a tavern on the way, and the next morning Parker's battered body was found in a field. His companion took a train to the capital, where he was arrested and charged with murder. The man later confessed to the crime, revealing at the same time where the murder weapons were hidden. The money for the headstone was donated by local residents.

**Kings Worthy
St Mary's Church
1912** 64469
Inside this fine church is an ancient font which dates back over 500 years. A window in the side chapel contains a small round panel of medieval glass drawn in gold depicting two mitred bishops with croziers. A commemorative tablet recalls the names of four brothers who were killed in the Great War. In the main entrance is a colourful tapestry depicting the village which was made by more than 30 people.

Around Southampton

Totton, St Mary's Church, Eling c1955 T243004
Close to Southampton Water lies the little church
of St Mary. Above the altar hangs an impressive
picture of the Last Supper painted by the Venetian
artist Marziale. The chancel arch is a striking feature
of the church, as is the 15th-century tower. The
17th-century candelabra is decorated with a dove
carrying an olive branch.

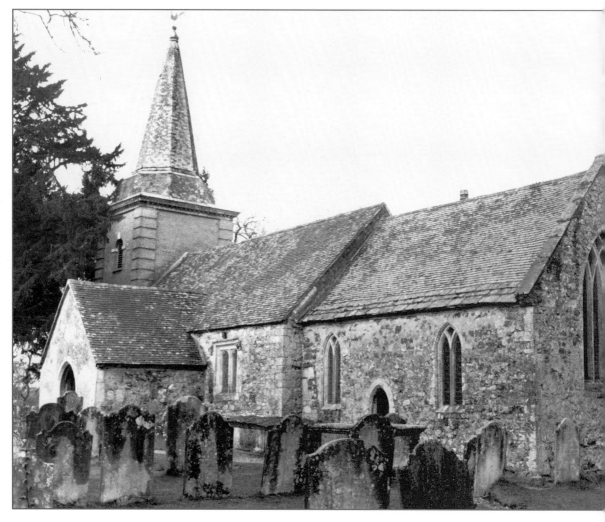

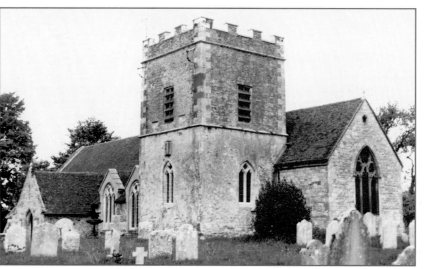

◄ **Boldre, St John the Baptist Church c1960**

B694001

Inside this delightful old church is a fascinating model of HMS 'Hood', which sank in 1941 with only three survivors. Visitors might wonder at first glance what the connection is between this church and the fateful warship. In fact, Vice-Admiral Holland, whose flagship it was, was a regular worshipper here. The church enjoys another noted link with the past. William Gilpin became vicar here in 1777, and later wrote several books on natural history.

◄ Brockenhurst
St Nicholas's Church c1960
B394014

The local church of St Nicholas, a short distance to the south of Brockenhurst railway station, is the only one in the New Forest mentioned in the Domesday Book. While you are there, have a look at the intricately carved grave of 'Brusher' Mills, a renowned local snake catcher who died in 1905. He earned his name by sweeping loose snow off the ice on Brockenhurst pond.

▼ Sopley
The Church of St Michael
and All Angels 1900 45064

One of the region's loveliest churches, stone-built St Michael and All Angels stands on a hillock overlooking the Avon and its picturesque valley. Above the sturdy tower rises a tiny spire; inside are various medieval carvings - one of which depicts a man with his tongue sticking out. General Sir George Willis is commemorated here, as is his grandfather, who was vicar of Sopley for 46 years.

◄ Fawley, All Saints
Church c1955 F150003

In the churchyard is the grave of Flight Lieutenant Kinkead, who was killed in 1928 over the Solent while trying to break the world air speed record. Back in the early 1960s the inhabitants of Tristan da Cunha were forced to leave their island when a volcano began to erupt. The islanders relocated to the former RAF married quarters at Calshot, and a model of one of their long-boats lies inside All Saints Church.

▼ **Fordingbridge, St Mary's Church c1965** F178049
The 700-year-old church looks out over Fordingbridge town centre, and displays Early English, Decorated and Perpendicular work. The beautifully-carved 15th-century roof in the north chancel chapel is outstanding.

▼ **Fordingbridge, St Mary's Church c1960** F178008
Inside the church is an ancient font, which was found in the vicarage garden. The royal arms over the door is an impressive piece of 18th-century woodcarving. An altar tomb in the outside wall of the lady chapel contains a stone scored with grooves, which are thought to have been made by the sharpening of swords in the Civil War.

▲ **Sway, The Parish Church of St Luke c1955** S638016
The village is famous for its tall tower, known as Peterson's Folly. Not far away from it lies this timeless New Forest church, which contains an early Christian relic. In the sanctuary stands a pottery urn with three handles and a scroll pattern in red and black. The urn, containing the ashes of a Christian convert from the 2nd century, was found in the Christian burial ground at Ramleh in Egypt.

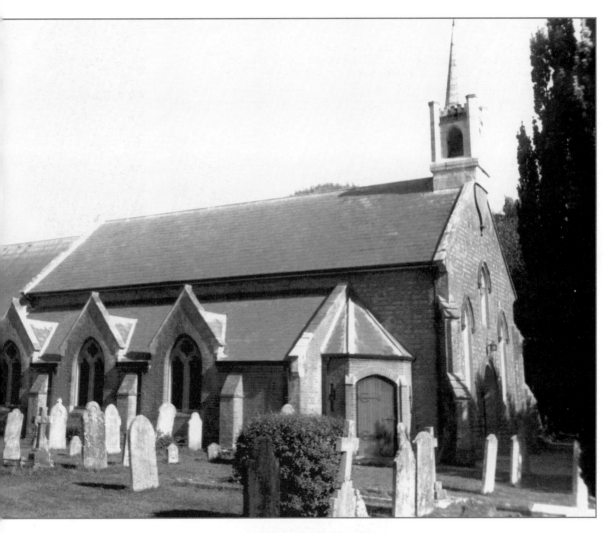

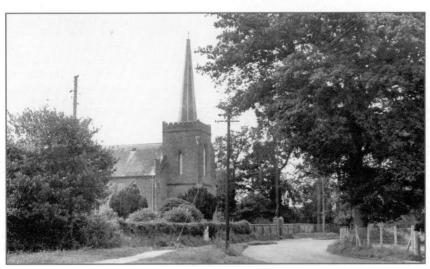

◄ **Bransgore**
The Church of St Mary
c1960 B695004
The 19th-century church includes a 16th-century font which came from Christchurch Priory. In a small chapel is an oak shrine superbly carved with linenfold pattern; it commemorates the names of the men of the village who died for their country.

**Ringwood
The Church of
St Peter and St Paul
from the Market
Place 1890** 24061
This famous market
town on the edge of
the New Forest has
an impressive church
which looks particularly
striking when seen from
the bridge over the
Avon. The church was
built in the Early English
style in the 19th
century, and contains
a 15th-century brass
to John Prophete.

▼ Milford-on-Sea, All Saints Church c1955 M303094

The church's most unusual feature is its extraordinary 13th-century tower and 14th-century leaded spire. The tower spreads out near its base and has been described as looking 'rather like a broody hen squatting over her chickens'. Note the two bizarre carved heads above the window of the south aisle of the church: one is of a man playing the bagpipes!

▼ New Milton, Old Milton Church c1965 N58009

The tower of this old church is about 300 years old, though the chancel is more recent and is divided from the nave by an oak screen and three round arches. Few buildings from the original settlement remain, and today New Milton is a sprawling coastal community made up mainly of 20th-century residential development.

▲ Lyndhurst, St Michael and All Angels Church 1891 29589

St Michael and All Angels was designed by William White, who trained under George Gilbert Scott. It contains a fresco painted by Frederick Leighton, which is reputed to be the first fresco painted in an English church since the Reformation. The fresco depicts the parable of the wise and foolish virgins.

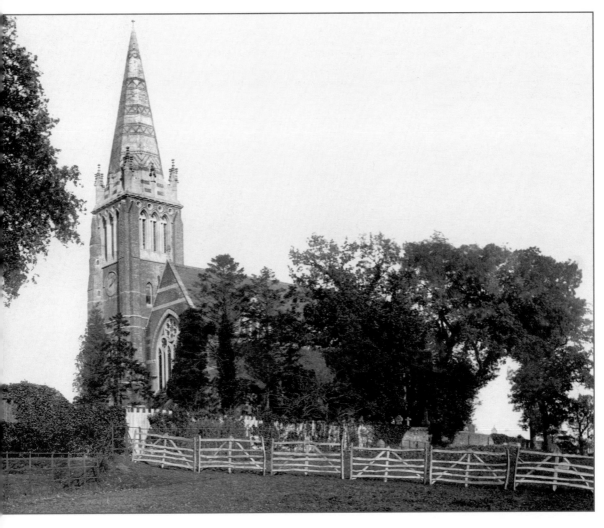

◀ **Lyndhurst, Emery Down Christ Church 1892** 31392 William Butterfield's church was built only twenty-eight years before this photograph was taken. The design is very eye-catching, with its blend of red brick and blue diapers. The roof has thin scissor-bracing. Some aspects of the church did not impress Pevsner: 'Stained glass all by the same deplorable artist', he comments in his guide to the county.

◀ **Beaulieu, The Abbey Church 1908** 60477
The church was once the refectory of the abbey, which almost certainly makes it unique among parish churches. One rare treasure here is the old pulpit from which readings were given to the monks at meal times. Founded as a Cistercian abbey by King John in 1204, Beaulieu is Norman-French for 'beautiful place'.

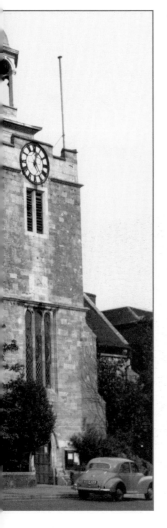

Lymington, St Thomas's Church c1955 L148118

The churchyard contains the tomb of Caroline Bowles, the second wife of the poet Robert Southey. She lived virtually all her life in a nearby cottage, and was a poet in her own right. There are several memorials in the chancel, one of which is to Matthew Blakiston. It reads: 'To those who knew him the enumeration of his virtues would be superfluous. To those who knew him not it might be tedious'.

▼ Netley, St Edward's Church c1955 N10004

The church of St Edward the Confessor contains a medieval effigy of a crusader monk, which was found in the wall of nearby Netley Castle and probably came from Netley Abbey.

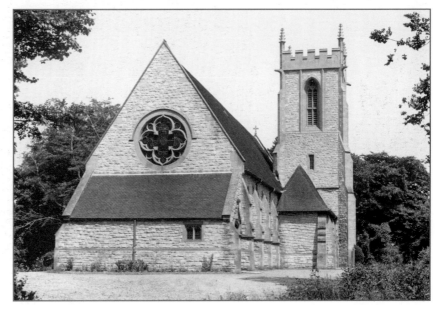

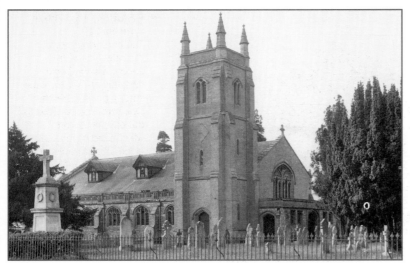

◄ Botley, All Saints Church c1955 B544001

Situated at the western end of the main street, All Saints Church has dormer windows with carved bargeboards and a diamond-shaped clock with a gilded crown. The clock comes from the stables of the 19th-century farmer and journalist William Cobbett. He lived at Fairthorn Farm, and described Botley as 'the most delightful village in the world'.

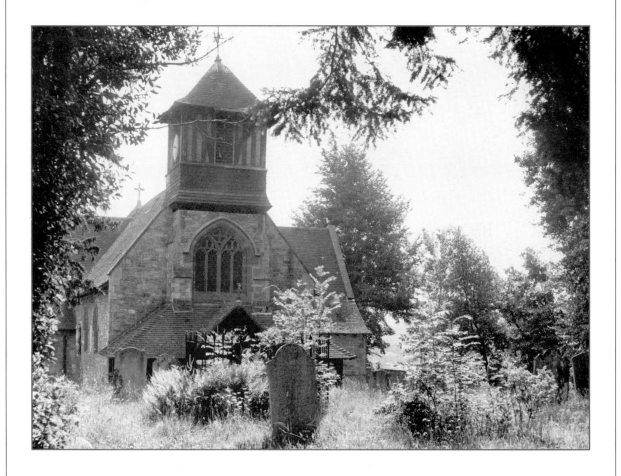

Bursledon
The Church c1955 B304001
The church stands halfway up a hill overlooking the village rooftops
and contains a large and impressive Norman font. The chancel
arch is 13th-century, and the church contains several memorials to
former shipbuilders, including Philemon Ewer who died in 1750.
Ewer built seven large ships of war for his majesty's service during
the wars with France and Spain.

Bursledon, The Church c1965 0112043
In an outer wall of the church, which was restored in the 19th century, are two superbly-carved 17th- and 18th-century tombstones, the former adorned with spades, flaming torches, cherubs and hourglasses.

Hamble, St Andrew's Church c1955 H148017
Sir Alliott Verdon-Roe, one of Britain's first aviators, is buried in this partly Norman church. St Andrew's was originally the church of the Benedictine priory of Hamble-le-Rice, which was founded in 1109. The long narrow nave has a fine Norman doorway, and there is a Norman arch in the south wall which led to the priory.

Swanmore
St Barnabas's Church c1965 S424028
St Barnabas's was originally a neo-Norman church
of 1846. A Gothic south aisle and north tower with
shingle spire were added to this building in the late
1870s. Built of flint and stone, the church has large
round-headed windows in the Norman sections.

Around Portsmouth

Wickham
St Nicholas's Church c1965 W491057
Extensively restored in 1862-63, St Nicholas's church contains a
carving of a centaur with a bow and arrow on one of the capitals
of the reset doorway. The church is also noted for its Uvedale
monument of 1615. William Uvedale and his wife are
accompanied by their kneeling children.

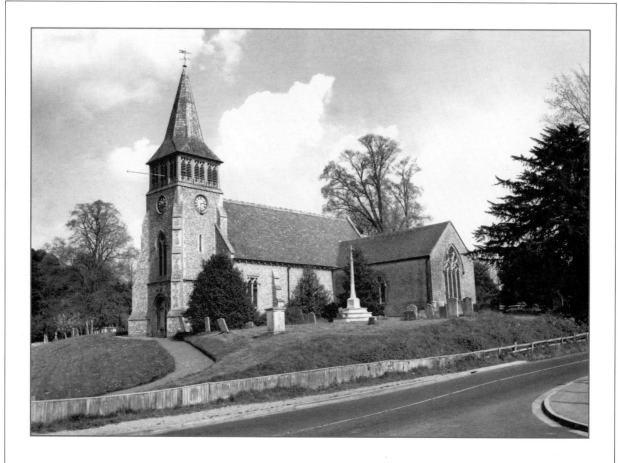

Wickham
St Nicholas's Church c1960 W491029
This flint-knapped church, standing on its own at the eastern end
of Wickham, includes a memorial to William Cummins. He arrived
in this parish in about 1763, and on his death 60 years later, he
bequeathed gifts to the value of £800.

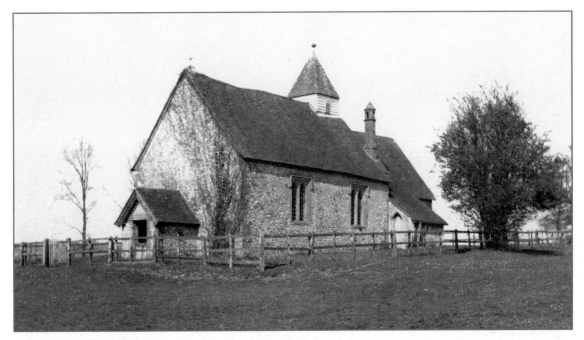

Rowlands Castle, St Hubert's Church, Idsworth c1955 R83032
One of Hampshire's most fascinating churches, St Hubert's stands on its own close to the Sussex border. During the Victorian era the church fell into disrepair, but it was restored in 1912. The nave, extended in the 16th century, dates back to about 950, and the wall paintings are among the most important in the county.

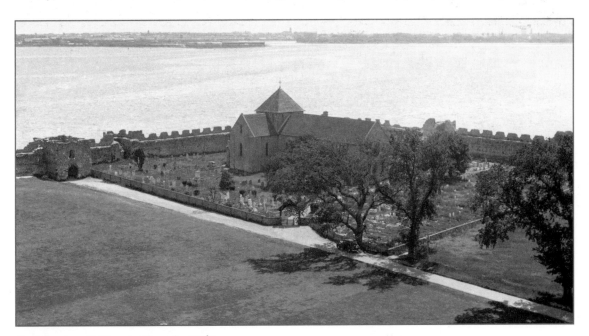

Portchester, St Mary's Church c1960 P73009
This ancient priory church occupies one of the loveliest settings in Hampshire. Overlooking Portsmouth Harbour and fanned by sea breezes, the church lies inside a Roman fort, which is thought to have been built towards the end of the 3rd century AD. Queen Anne contributed towards the restoration of the church in 1710, and the church includes a Norman arch with carved capitals. Above the capitals are the fish and bowmen of the zodiac.

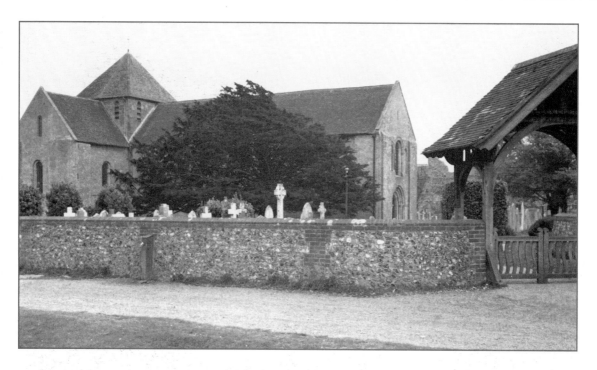

▲ **Portchester**
St Mary's Church c1960
P73035
During the early part of the 17th century, busts began to take the place of effigies; the county's earliest bust can be found here, on the memorial to Sir Thomas Cornwallis, one-time governor of the castle. Portchester is one of the largest of the 'Saxon shore' forts, and it was regularly used by kings when they visited Portsmouth. Henry VIII came here with Anne Boleyn.

Farlington ▶
St Andrew's Church c1960
F165001
This small church on the outskirts of Portsmouth dates from 1872, and the north aisle from 1875. On seeing St Andrew's, Pevsner observed: 'At first sight the external effect is rather odd, with the chancel roof rising higher than that of the nave'.

Alverstoke
St Mary's Church 1898 42725
Once a small village on the Haslar Creek, Alverstoke was eventually
swallowed up by Gosport. The church has a long association with
maritime history. Captain Bligh, who was wounded at the Battle
of Trafalgar, was buried here in 1835. Six local watermen from
Gosport carried his coffin to the tomb; on Bligh's instructions,
each of them received a sovereign and a new suit.

▲ Purbrook, St John the Baptist's Church c1960 P340003
Notice the steep angle of the roof in this photograph. The 19th-century church and boundary walls are built of flint, and the square tower has a pyramidal cap. Inside, the church conveys a lofty feeling.

**Hayling Island ▶
The Church of St Mary the Virgin c1965**
H400002
This is one of two churches on Hayling Island, a popular holiday spot linked to the mainland by a bridge. St Mary the Virgin dates back to the 13th century, and is situated in the southern part of the island. The porch is 15th-century; the lancets of the east window are superbly decorated with figures of saints.

Emsworth, St James's Church c1955 E62007
The tradition of illustrating the Gospels is reflected in the modern altar piece, which depicts incidents from the life of St James. The church dates back to 1839-40; it has a distinctive neo-Norman style west front, with a big round-headed window and staircases flanking the entrance. Lombardic colonnades and side turrets can also be seen in this photograph.

Fareham, Holy Trinity Church c1965 F103051
Close to the town centre and similar to All Saints in Portsmouth, Holy Trinity dates back to the 1830s. The nave, aisles, chancel and west tower are all distinguished by local yellow brick with stone dressings. The tower, surmounted by a short stone spire, is bolstered by tiered buttresses with stone gables which curve to a spearhead point.

Horndean, Blendworth, Holy Trinity Church c1955 H403009
The prominent spire of this mid 19th-century church is set against a backdrop of trees; the spire has sharp gables where it rises from the tower. A striking mosaic dado adorns its interior walls, and there is a needlework picture of the Virgin and Child.

Stubbington, Holy Rood Church c1965 S636076
The original plan with this restored 19th-century church was for it to have a spire, though it never materialised. There is yellow brickwork on the inside wall surfaces and painted tiles depicting saints on the chancel walls. The east window has stained glass dating back to the late 1940s.

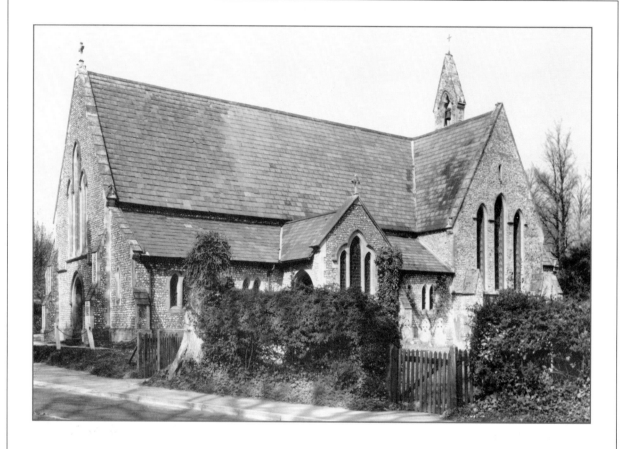

Rowlands Castle
St John's Church c1955 R83039
Originally a cruciform church of 1838, St John's has a complex
pattern of roof timbers at the crossing and a series of virtually
life-size carved heads in the spandrels of the arcades.

Index

Frith Book Co Titles

www.francisfrith.co.uk

The Frith Book Company publishes over 100 new titles each year. A selection of those currently available are listed below. For latest catalogue please contact Frith Book Co.

Town Books 96pages, approx 100 photos. County and Themed Books 128pages, approx 150 photos (unless specified). All titles hardback laminated case and jacket except those indicated pb (paperback)

Title	ISBN	Price
Ancient Monuments & Stone Circles	1-85937-143-4	£17.99
Aylesbury (pb)	1-85937-227-9	£9.99
Bakewell	1-85937-113-2	£12.99
Barnstaple (pb)	1-85937-300-3	£9.99
Bath	1-85937-097-7	£12.99
Bedford (pb)	1-85937-205-8	£9.99
Berkshire (pb)	1-85937-191-4	£9.99
Berkshire Churches	1-85937-170-1	£17.99
Bognor Regis (pb)	1-85937-431-x	£9.99
Bournemouth	1-85937-067-5	£12.99
Bradford (pb)	1-85937-204-x	£9.99
Brighton & Hove(pb)	1-85937-192-2	£8.99
Bristol (pb)	1-85937-264-3	£9.99
British Life A Century Ago (pb)	1-85937-213-9	£9.99
Buckinghamshire (pb)	1-85937-200-7	£9.99
Camberley (pb)	1-85937-222-8	£9.99
Cambridge (pb)	1-85937-422-0	£9.99
Cambridgeshire (pb)	1-85937-420-4	£9.99
Canals & Waterways (pb)	1-85937-291-0	£9.99
Canterbury Cathedral (pb)	1-85937-179-5	£9.99
Cardiff (pb)	1-85937-093-4	£9.99
Carmarthenshire	1-85937-216-3	£14.99
Cheltenham (pb)	1-85937-095-0	£9.99
Cheshire (pb)	1-85937-271-6	£9.99
Chester	1-85937-090-x	£12.99
Chesterfield	1-85937-071-3	£9.99
Chichester (pb)	1-85937-228-7	£9.99
Colchester (pb)	1-85937-188-4	£8.99
Cornish Coast	1-85937-163-9	£14.99
Cornwall (pb)	1-85937-229-5	£9.99
Cornwall Living Memories	1-85937-248-1	£14.99
Cotswolds (pb)	1-85937-230-9	£9.99
Cotswolds Living Memories	1-85937-255-4	£14.99
County Durham	1-85937-123-x	£14.99
Cumbria	1-85937-101-9	£14.99
Dartmoor	1-85937-145-0	£14.99
Derbyshire (pb)	1-85937-196-5	£9.99
Devon (pb)	1-85937-297-x	£9.99
Dorset (pb)	1-85937-269-4	£9.99
Dorset Churches	1-85937-172-8	£17.99
Dorset Coast (pb)	1-85937-299-6	£9.99
Dorset Living Memories	1-85937-210-4	£14.99
Down the Severn	1-85937-118-3	£14.99
Down the Thames (pb)	1-85937-278-3	£9.99
Dublin (pb)	1-85937-231-7	£9.99
East Anglia (pb)	1-85937-265-1	£9.99
East London	1-85937-080-2	£14.99
East Sussex	1-85937-130-2	£14.99
Eastbourne	1-85937-061-6	£12.99
Edinburgh (pb)	1-85937-193-0	£8.99
English Castles (pb)	1-85937-434-4	£9.99
English Country Houses	1-85937-161-2	£17.99
Exeter	1-85937-126-4	£12.99
Exmoor	1-85937-132-9	£14.99
Falmouth	1-85937-066-7	£12.99
Folkestone (pb)	1-85937-124-8	£9.99
Glasgow (pb)	1-85937-190-6	£9.99
Gloucestershire	1-85937-102-7	£14.99
Greater Manchester (pb)	1-85937-266-x	£9.99
Hampshire Churches (pb)	1-85937-207-4	£9.99
Harrogate	1-85937-423-9	£9.99
Hastings & Bexhill (pb)	1-85937-131-0	£9.99
Heart of Lancashire (pb)	1-85937-197-3	£9.99
Helston (pb)	1-85937-214-7	£9.99
Hereford (pb)	1-85937-175-2	£9.99
Herefordshire	1-85937-174-4	£14.99
Humberside	1-85937-215-5	£14.99
Hythe, Romney Marsh & Ashford	1-85937-256-2	£9.99
Ipswich (pb)	1-85937-424-7	£9.99
Ireland (pb)	1-85937-181-7	£9.99
Isles of Scilly	1-85937-136-1	£14.99
Isle of Wight (pb)	1-85937-429-8	£9.99
Isle of Wight Living Memories	1-85937-304-6	£14.99
Kent (pb)	1-85937-189-2	£9.99
Kent Living Memories	1-85937-125-6	£14.99
Lake District (pb)	1-85937-275-9	£9.99
Lancaster, Morecambe & Heysham (pb)	1-85937-233-3	£9.99
Leeds (pb)	1-85937-202-3	£9.99
Leicester	1-85937-073-x	£12.99
Leicestershire (pb)	1-85937-185-x	£9.99
Lighthouses	1-85937-257-0	£17.99
Lincolnshire (pb)	1-85937-433-6	£9.99

Available from your local bookshop or from the publisher

Frith Book Co Titles (continued)

Liverpool & Merseyside (pb)	1-85937-234-1	£9.99	Southampton (pb)	1-85937-427-1	£9.99
London (pb)	1-85937-183-3	£9.99	Southport (pb)	1-85937-425-5	£9.99
Ludlow (pb)	1-85937-176-0	£9.99	Stratford upon Avon	1-85937-098-5	£12.99
Luton (pb)	1-85937-235-x	£9.99	Suffolk (pb)	1-85937-221-x	£9.99
Manchester (pb)	1-85937-198-1	£9.99	Suffolk Coast	1-85937-259-7	£14.99
New Forest	1-85937-128-0	£14.99	Surrey (pb)	1-85937-240-6	£9.99
Newport, Wales (pb)	1-85937-258-9	£9.99	Sussex (pb)	1-85937-184-1	£9.99
Newquay (pb)	1-85937-421-2	£9.99	Swansea (pb)	1-85937-167-1	£9.99
Norfolk (pb)	1-85937-195-7	£9.99	Tees Valley & Cleveland	1-85937-211-2	£14.99
Norfolk Living Memories	1-85937-217-1	£14.99	Thanet (pb)	1-85937-116-7	£9.99
Northamptonshire	1-85937-150-7	£14.99	Tiverton (pb)	1-85937-178-7	£9.99
Northumberland Tyne & Wear (pb)	1-85937-281-3	£9.99	Torbay	1-85937-063-2	£12.99
North Devon Coast	1-85937-146-9	£14.99	Truro	1-85937-147-7	£12.99
North Devon Living Memories	1-85937-261-9	£14.99	Victorian and Edwardian Cornwall	1-85937-252-x	£14.99
North Wales (pb)	1-85937-298-8	£9.99	Victorian & Edwardian Devon	1-85937-253-8	£14.99
North Yorkshire (pb)	1-85937-236-8	£9.99	Victorian & Edwardian Kent	1-85937-149-3	£14.99
Norwich (pb)	1-85937-194-9	£8.99	Vic & Ed Maritime Album	1-85937-144-2	£17.99
Nottingham (pb)	1-85937-324-0	£9.99	Victorian and Edwardian Sussex	1-85937-157-4	£14.99
Nottinghamshire (pb)	1-85937-187-6	£9.99	Victorian & Edwardian Yorkshire	1-85937-154-x	£14.99
Peak District (pb)	1-85937-280-5	£9.99	Victorian Seaside	1-85937-159-0	£17.99
Penzance	1-85937-069-1	£12.99	Villages of Devon (pb)	1-85937-293-7	£9.99
Peterborough (pb)	1-85937-219-8	£9.99	Villages of Kent (pb)	1-85937-294-5	£9.99
Piers	1-85937-237-6	£17.99	Warwickshire (pb)	1-85937-203-1	£9.99
Plymouth	1-85937-119-1	£12.99	Welsh Castles (pb)	1-85937-322-4	£9.99
Poole & Sandbanks (pb)	1-85937-251-1	£9.99	West Midlands (pb)	1-85937-289-9	£9.99
Preston (pb)	1-85937-212-0	£9.99	West Sussex	1-85937-148-5	£14.99
Reading (pb)	1-85937-238-4	£9.99	West Yorkshire (pb)	1-85937-201-5	£9.99
Salisbury (pb)	1-85937-239-2	£9.99	Weymouth (pb)	1-85937-209-0	£9.99
St Ives	1-85937-068-3	£12.99	Wiltshire (pb)	1-85937-277-5	£9.99
Scotland (pb)	1-85937-182-5	£9.99	Wiltshire Churches (pb)	1-85937-171-x	£9.99
Scottish Castles (pb)	1-85937-323-2	£9.99	Wiltshire Living Memories	1-85937-245-7	£14.99
Sheffield, South Yorks (pb)	1-85937-267-8	£9.99	Winchester (pb)	1-85937-428-x	£9.99
Shrewsbury (pb)	1-85937-325-9	£9.99	Windmills & Watermills	1-85937-242-2	£17.99
Shropshire (pb)	1-85937-326-7	£9.99	Worcestershire	1-85937-152-3	£14.99
Somerset	1-85937-153-1	£14.99	York (pb)	1-85937-199-x	£9.99
South Devon Coast	1-85937-107-8	£14.99	Yorkshire (pb)	1-85937-186-8	£9.99
South Devon Living Memories	1-85937-168-x	£14.99	Yorkshire Living Memories	1-85937-166-3	£14.99
South Hams	1-85937-220-1	£14.99			

Frith Book Co titles available soon

1870's England	Oct 01	1-85937-331-3	£17.99	Gloucester (pb)	Oct 01	1-85937-417-4	£9.99
Amersham & Chesham (pb)	Oct 01	1-85937-340-2	£9.99	Oxfordshire (pb)	Oct 01	1-85937-430-1	£9.99
Bedfordshire	Oct 01	1-85937-320-8	£14.99	Picturesque Harbours	Oct 01	1-85937-208-2	£17.99
Belfast (pb)	Oct 01	1-85937-303-8	£9.99	Romford (pb)	Oct 01	1-85937-319-4	£9.99
Britain Living Memories	Oct 01	1-85937-343-7	£17.99	Villages of Sussex (pb)	Sep 01	1-85937-295-3	£9.99
Chelmsford (pb)	Oct 01	1-85937-310-0	£9.99	Worcester (pb)	Oct 01	1-85937-165-5	£9.99

See Frith books on the internet www.francisfrith.co.uk

FRITH PRODUCTS & SERVICES

Francis Frith would doubtless be pleased to know that the pioneering publishing venture he started in 1860 still continues today. A hundred and forty years later, The Francis Frith Collection continues in the same innovative tradition and is now one of the foremost publishers of vintage photographs in the world. Some of the current activities include:

Interior Decoration

Today Frith's photographs can be seen framed and as giant wall murals in thousands of pubs, restaurants, hotels, banks, retail stores and other public buildings throughout the country. In every case they enhance the unique local atmosphere of the places they depict and provide reminders of gentler days in an increasingly busy and frenetic world.

Product Promotions

Frith products are used by many major companies to promote the sales of their own products or to reinforce their own history and heritage. Frith promotions have been used by Hovis bread, Courage beers, Scots Porage Oats, Colman's mustard, Cadbury's foods, Mellow Birds coffee, Dunhill pipe tobacco, Guinness, and Bulmer's Cider.

Genealogy and Family History

As the interest in family history and roots grows world-wide, more and more people are turning to Frith's photographs of Great Britain for images of the towns, villages and streets where their ancestors lived; and, of course, photographs of the churches and chapels where their ancestors were christened, married and buried are an essential part of every genealogy tree and family album.

Frith Products

All Frith photographs are available Framed or just as Mounted Prints and Posters (size 23 x 16 inches). These may be ordered from the address below. From time to time other products - Address Books, Calendars, Table Mats, etc - are available.

The Internet

Already twenty thousand Frith photographs can be viewed and purchased on the internet through the Frith websites and a myriad of partner sites.

For more detailed information on Frith companies and products, look at these sites:

www.francisfrith.co.uk
www.francisfrith.com
(for North American visitors)

See the complete list of Frith Books at:
www.francisfrith.co.uk
This web site is regularly updated with the latest list of publications from the Frith Book Company. If you wish to buy books relating to another part of the country that your local bookshop does not stock, you may purchase on-line.

For further information, trade, or author enquiries please contact us at the address below:
The Francis Frith Collection, Frith's Barn, Teffont, Salisbury, Wiltshire, England SP3 5QP.
Tel: +44 (0)1722 716 376 Fax: +44 (0)1722 716 881 Email: sales@francisfrith.co.uk

See Frith books on the internet www.francisfrith.co.uk

TO RECEIVE YOUR FREE MOUNTED PRINT

Mounted Print
Overall size 14 x 11 inches

Cut out this Voucher and return it with your remittance for £1.95 to cover postage and handling, to UK addresses. For overseas addresses please include £4.00 post and handling. Choose any photograph included in this book. Your SEPIA print will be A4 in size, and mounted in a cream mount with burgundy rule line, overall size 14 x 11 inches.

Order additional Mounted Prints at HALF PRICE (only £7.49 each*)

If there are further pictures you would like to order, possibly as gifts for friends and family, purchase them at half price (no additional postage and handling required).

Have your Mounted Prints framed*

For an additional £14.95 per print you can have your chosen Mounted Print framed in an elegant polished wood and gilt moulding, overall size 16 x 13 inches (no additional postage and handling required).

*** IMPORTANT!**
These special prices are only available if ordered using the original voucher on this page (no copies permitted) and at the same time as your free Mounted Print, for delivery to the same address

Frith Collectors' Guild

From time to time we publish a magazine of news and stories about Frith photographs and further special offers of Frith products. If you would like 12 months FREE membership, please return this form.

Send completed forms to:
**The Francis Frith Collection,
Frith's Barn, Teffont, Salisbury,
Wiltshire SP3 5QP**

Voucher for **FREE** and Reduced Price Frith Prints

Picture no.	Page number	Qty	Mounted @ £7.49	Framed + £14.95	Total Cost
		1	**Free of charge***	£	£
			£7.49	£	£
			£7.49	£	£
			£7.49	£	£
			£7.49	£	£
			£7.49	£	£

Please allow 28 days for delivery	*** Post & handling**	**£1.95**
Book Title	**Total Order Cost**	**£**

Please do not photocopy this voucher. Only the original is valid, so please cut it out and return it to us.

I enclose a cheque / postal order for £
made payable to 'The Francis Frith Collection'
OR please debit my Mastercard / Visa / Switch / Amex card
(credit cards please on all overseas orders)

Number .

Issue No(Switch only)Valid from (Amex/Switch)

Expires Signature .

Name Mr/Mrs/Ms .

Address .

. .

. Postcode

Daytime Tel No . Valid to 31/12/02

The Francis Frith Collectors' Guild

Please enrol me as a member for 12 months free of charge.

Name Mr/Mrs/Ms .

Address .

. .

. .

. Postcode

Would you like to find out more about Francis Frith?

We have recently recruited some entertaining speakers who are happy to visit local groups, clubs and societies to give an illustrated talk documenting Frith's travels and photographs. If you are a member of such a group and are interested in hosting a presentation, we would love to hear from you.

Our speakers bring with them a small selection of our local town and county books, together with sample prints. They are happy to take orders. A small proportion of the order value is donated to the group who have hosted the presentation. The talks are therefore an excellent way of fundraising for small groups and societies.

Can you help us with information about any of the Frith photographs in this book?

We are gradually compiling an historical record for each of the photographs in the Frith archive. It is always fascinating to find out the names of the people shown in the pictures, as well as insights into the shops, buildings and other features depicted.

If you recognize anyone in the photographs in this book, or if you have information not already included in the author's caption, do let us know. We would love to hear from you, and will try to publish it in future books or articles.

Our production team

Frith books are produced by a small dedicated team at offices in the converted Grade II listed 18th-century barn at Teffont near Salisbury, illustrated above. Most have worked with the Frith Collection for many years. All have in common one quality: they have a passion for the Frith Collection. The team is constantly expanding, but currently includes:

Jason Buck, John Buck, Heather Crisp, Isobel Hall, Rob Hames, Hazel Heaton, Peter Horne, James Kinnear, Tina Leary, Eliza Sackett, Terence Sackett, Sandra Sanger, Shelley Tolcher, Susanna Walker, Clive Wathen, Jenny Wathen and Douglas Burns.